Portrait of –

BUXTON

John Creighton

Sigma Leisure – Wilmslow

First published in 1989 by
Sigma Leisure, an imprint of **Sigma Press** 1 South Oak Lane, Wilmslow, SK9 6AR, England.

British Library Cataloguing in Publication Data
A CIP catalogue record for this book is available from the British Library.

ISBN: 1-85058-161-4

Typesetting by
Sigma Hi-Tech Services Ltd

Printed by
Manchester Free Press

Acknowledgments
The author wishes to thank the following, who kindly provided photographs and information for this book: Blue John Cavern; Buxton Advertiser; Derbyshire Museum Service; Derbyshire Library Service; Devonshire Royal Hospital; Explosions and Flame Laboratory; Ferodo Ltd; Haddon Hall; ICI Chemicals and Polymers Ltd; National Tramway Museum; Peak Rail Steam Centre; Ron Duggins; Speedwell Cavern; Treak Cliff Cavern.

Front Cover: Buxton Pavilion in the early 1880s; top hats and long skirts were the order of the day.

CONTENTS

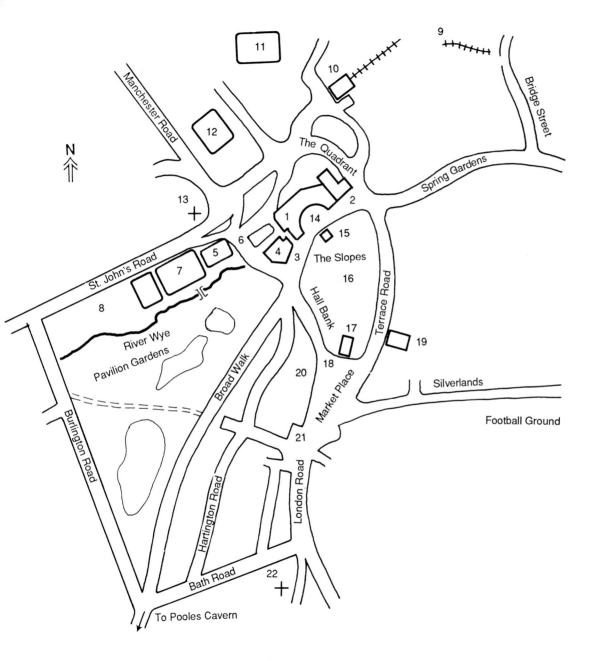

N

Key to Map

1. The Crescent
2. Former Thermal Baths
3. Tourist Information Centre
4. Old Hall Hotel
5. Opera House
6. The Square
7. The Pavilion
8. Swimming Pool
9. Buxton Steam Centre
10. Railway Station
11. Palace Hotel
12. Devonshire Royal Hospital
13. St. John the Baptist Church
14. St Ann's Well
15. The Micrarium
16. The Weather Station
17. The Town Hall
18. "King's Head Hotel"
19. Museum and Art Gallery
20. "Eagle Hotel"
21. Market Cross
22. Church of St. Ann

Chapter 1: History and Development

For many people the name Buxton conjures up a number of thoughts - spa resort, heavy snowfalls, one of the highest towns in Britain. It is hoped that this book will demonstrate that Buxton has much more to offer. For example, Mary, Queen of Scots stayed here, the Devonshire Royal Hospital has one of the biggest domes in Europe, and Poole's Cavern is named after a 15th century outlaw who stored his booty there.

The district abounds in superlatives. Chatsworth House is Derbyshire's largest stately home, the deepest cave in Britain is discovered at Castleton, while the Peak District National Park is the country's oldest urban park.

Set in the heart of the Peak District, 1000 feet above sea level, Buxton is Derbyshire's highest town and the second highest market town in England. Nestling in the grandeur of Derbyshire hills, Buxton provides an interesting mélange of town and country attractions. The spa is within easy reach of large conurbations, lying 25 miles from Manchester and 29 miles from Sheffield.

Early Man and the Romans

Records suggest that man first came to the Buxton area in the Middle Stone Age, and people certainly inhabited the district in the Neolithic era. Reminders of the Bronze Age have been discovered in a number of localities, in particular Grinlow, Silverlands and Harpur Hill.

During the Iron Age some earthworks were built in the region, including the famous one at Mam Tor. Excavations undertaken in the Lismore Road area have uncovered fragments of flint 7,000 years old and some pottery dating to the Neolithic period.

It is likely that the Romans constructed a fort, possibly on the site of today's football ground. They named it *'Aqua Arnemetiae'* - water sacred to the goddess *Arnemetia*. Curiously, she was a Celtic deity and this has given rise to the theory that Celts lived in the Buxton district.

The Romans liked bathing and it is clear that the area round the Crescent served the local troops who may have inhabited the Silverlands district of the town.

It is probable that by AD 78 a Roman fort existed in or around Buxton, although there is no hard evidence to support this. The routes leading from the town indicate a Roman presence and, in fact, during the mid-19th century a milestone was unearthed at Silverlands, showing the mileage to Navio (Brough) where there was a Roman fort. This milestone is now housed in Buxton's Museum and Art Gallery. Local evidence also suggests that Roman roads ran from the town towards Northwich and to Manchester.

The discovery in 1975 of over 200 Roman coins, bracelets and a clasp in the Gentlemen's

Public Bath contributed much to the Roman occupation theory. One main reason is that at least one coin dates from every emperor's reign, indicating a lengthy settlement in the district of some 300 years.

The Roman occupation of the region is further substantiated by the discovery of baths in the 17th and 18th centuries, and the remains from Roman days uncovered at Poole's Cavern. In fact, at Staden, just south of Buxton, there may have been a Romano-British settlement, since fragments of pottery found there can be dated as Roman. The site, overlooking Duke's Drive, was excavated in the early 1980s.

The Roman era drew to a close in 410 and the Christian influence made its mark on the area. In the 7th century the inhabitants of north Derbyshire were called *Pecsaetan* or Peak Dwellers, and barrows at Hurdlow and Benty Grange date from this period.

The Vikings arrived on the scene around 874, although there is no mention of Buxton. It was Bakewell in the 10th century which became an important fortified place in the time of Edward the Elder.

Buxton's Name

Buxton is not mentioned in the Domesday Survey but it could still have existed. About 1070 the land around the town went to William Peverel. It is early in the 12th century that Buckstones (Buxton) is first recorded and its origins are probably connected with rocking or bow stones (Old English *'bug stan'*) which could be found at Long Hill and at Fairfield. This last place was a popular hunting place for the kings of England who stayed at the Castle of the Peak or 'Castleton'. The foundation charter of Lenton Priory granted by William Peverel refers to 'Buckestones' and 'Bucstones' in the early 12th century.

Interestingly, right up to the mid-12th century, Buxton folk paid their dues to Peverel, and it is in 1244 that one discovers references to grantees having some influence over Buxton. A few years later, in 1262, lands in Buxton-le-Grene were sold by William of Buxstons to Richard and Mary of Goyt, moving in 1263 to the control of Adam de Gesem.

Some observers would argue that a major event in the 13th century was the construction of a mill in today's Ashwood Park. It was also about this period that Fairfield residents received a chapel. At the close of the 1300s 140 people were residing in Buxton.

Buxton Waters

When did the famed waters start to play a prominent part in Buxton's history? Clearly, the place was a spa centre during Roman times, but the first recorded reference to the well does not appear until 1460. However, it is likely that a chapel stood near the springs as far back as

Opposite:
This scene from the 1950s is a reminder that on average, Buxton endures 40 days of snow a year. Here a bulldozer attempts to clear a path in front of houses whose doors are blocked by snow. The little shop is just about recognisable by its advertisements for Lyon's Tea and Bourneville chocolate.

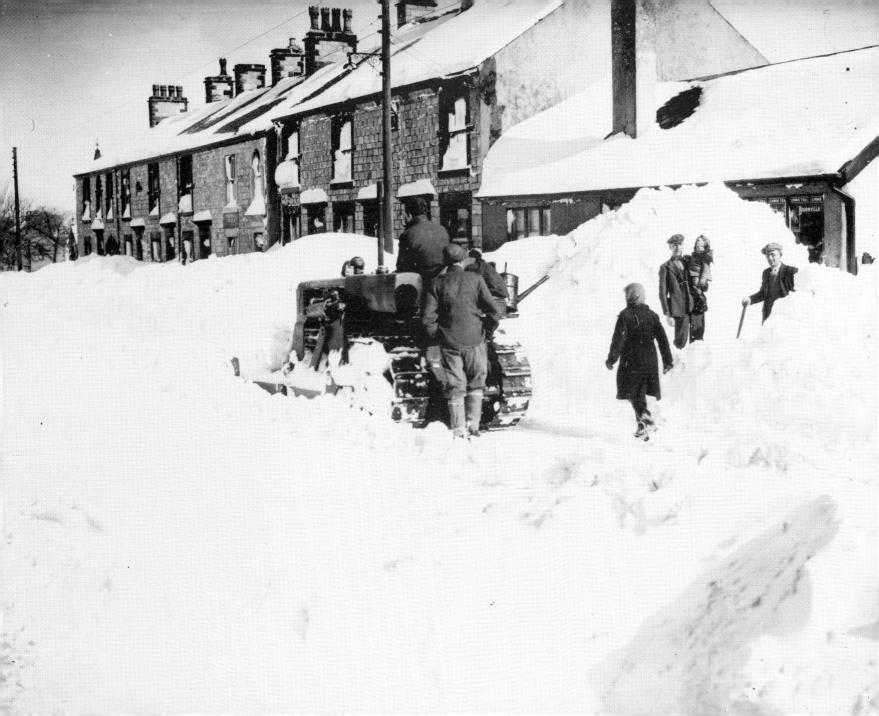

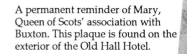

A permanent reminder of Mary, Queen of Scots' association with Buxton. This plaque is found on the exterior of the Old Hall Hotel.

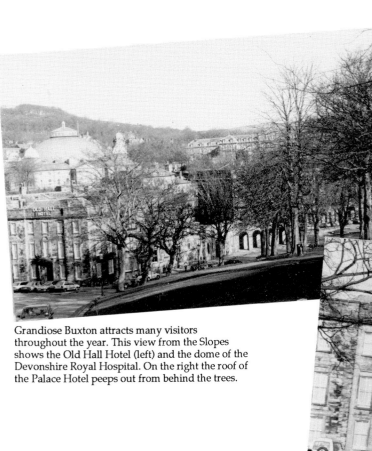

Grandiose Buxton attracts many visitors throughout the year. This view from the Slopes shows the Old Hall Hotel (left) and the dome of the Devonshire Royal Hospital. On the right the roof of the Palace Hotel peeps out from behind the trees.

Mary, Queen of Scots visited Buxton on several occasions, spending some time in the Old Hall.

1190. 15th century documents mention some lands at 'Buckston juxta Halywall', and it is evident that the last word refers to a holy well whose waters had curative properties.

The association with St. Ann is first recorded in 1524, although it is not apparent why this particular saint was chosen. Some pundits would argue that the statue of a goddess was found in the 16th century, bearing the name *'Arnemetia'*, and that many construed this to read 'Ann'.

Despite the obscurity surrounding the saint's association with the well, people chose to believe in a religious presence and this brought the chapel into prominence. However, under Henry VIII's orders the well and chapel were closed in 1538 during the Dissolution of the Monasteries and his Secretary of State, Thomas Cromwell, was sent the statue of St. Ann.

Local sources indicate that the well and chapel were not closed for too long, and by 1570 they were reopened at a time when the village came under the auspices of the Cavendish family.

Mary, Queen of Scots

She stayed at a number of places in the region, including Sheffield and Chatsworth. In fact, she was a prisoner at the latter at various times between 1569 and 1584. Because of his allegiance of the Crown, the Earl of Shrewsbury was put in charge of Mary in 1569. The Old Hall Hotel (see Chapter 2: 'Architectural Heritage') occupies the site of a house erected by the Earl in 1572-73. It had accommodation for 30 guests and was renovated in 1670 by the Duke of Devonshire.

Mary first visited Buxton in 1573, taking the waters to alleviate her rheumatism, and she stayed at the Hall during her course of treatment.

It was in 1573 that one Dr. Junius Jones described the Hall as, "a very goodly house, four storeys high". Queen Mary, the Earl of Pembroke, the Earl of Leicester were among many Elizabethans of note who scratched their signatures and verses on the Hall's window panes. Mary etched her famous couplet on a piece of glass in 1584:

'Buxtona, qua calidae celebrabere nomine lympha,
Forte mihi posthae no adeunda vale.
Marie Scotia.'

'Buxton, whose warm waters have made thy name famous,
perchance I shall visit thee no more.
Farewell. Mary, Queen of Scots.'

Formerly called 'The Eagle and Child', this hostelry was one of the main coaching inns during the 18th century.

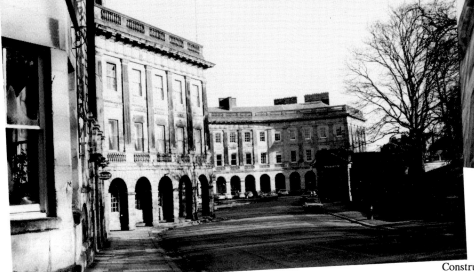

Constructed in 1780-88, the imposing Crescent is 360 feet in length and contains 378 windows. It was financed by the fifth Duke of Devonshire from the profits of his copper mines.

The presence of royalty attracted many others to the township and soon notables from around the country journeyed to Buxton to try the waters. However, poor people were hindered by a law requiring them to obtain a licence before visiting the town.

Moving into the 17th century, a map exists from 1610 depicting the Hall (which had been built over a bath) and St. Ann's Well, then a separate structure alongside the Hall.

St. Anne's Church bears the date 1625 but the building existed before this time and, in fact, it was originally dedicated to St. John. This was an attempt to oppose any veneration to St. Anne, but soon the name of St. John was superseded by that of the female saint.

1647 saw the foundation of Buxton School, with a charity school opening in Fairfield 15 years later. When the Hall was rebuilt in 1670 or thereabouts, it left much to be desired according to guests who stayed there (see Chapter 2).

Georgian Times

At the start of the 18th century Buxton was still a small village hiding in the Pennines. However, the advent of the Georgian era was to change all this as considerable development of the area took place. Perhaps the biggest fillip was provided by the fifth Duke of Devonshire who introduced some ambitious planning schemes. This should not overshadow work by Sir Thomas Delve of Doddington Hall, Cheshire in 1709. Although demolishing some Roman remains in the process, he rebuilt St. Ann's Well, and constructed a building 12 feet square in which a small basin contained the water which bubbled into it.

In 1710 the second Duke of Devonshire gave instructions for the reconstruction of the baths and stables near the Hall, and two years later a stone vault had been constructed over the baths. This offered protection from the elements to 20 people who could swim or walk in the tepid waters. Bathers enjoyed the springs issuing forth inside the two baths, one measuring 26 feet 6 inches by 12 feet 8 inches, the other 17 feet by 10 feet 2 inches.

The continuing interest in Buxton's waters encouraged development of the village and also led to improved communications. For instance, Derbyshire's first turnpike connected Buxton to Manchester (1724), while routes to Sheffield and Macclesfield opened in 1758 and 1759 respectively.

It soon became apparent that existing hotels could not cope with the influx of 18th century visitors. So Buxton experienced a considerable amount of building, which included improved bathing facilities for those wishing to take the waters.

The 18th century witnessed the greatest development of Buxton as a famous spa, mainly because of the interest shown by the fifth Duke of Devonshire. He built the pleasant Duke's Drive in 1793, while the Crescent was constructed by order of him in 1780-88. The Duke enlisted the help of York architect John Carr to assist in his revamping of the village and

building the Crescent. Carr was also instrumental in constructing a new St. Ann's Well. The one dating from 1709 was pulled down in 1782, its replacement opening the following year, measuring 15 feet square and providing free drinking water.

With increasingly large numbers of tourists taking the waters, accommodation was becoming a problem and so the Great Stables were built to house grooms and horses, while their masters enjoyed the comfort of the Crescent. The stables were later altered to become the Devonshire Hospital.

The Square was the work of John White between 1802 and 1803. One of its purposes was to hide the rear of the Hall and the Baths. In 1811 worshippers were provided with a new Parish church, dedicated to St. John the Baptist. Prior to this, services had been held in the Assembly Room, since the cramped conditions in St. Anne's Church could not accommodate large congregations.

It was about 1818 that the first 'Thermal Baths' or 'Hot Baths' were built by a Mr Sylvester. Lined with porcelain and marble, they were extended in 1852-53.

The Nineteenth Century

Buxton was still a small place in the early 19th century, with under a thousand permanent residents in 1815. It was the growing number of visitors which encouraged development rather than the locals who lived in just 200 houses. Consequently, the Serpentine Walks and St. Ann's Cliff (the Slopes) were laid out by Sir Jeffrey Wyatville in 1818. The Walks have been a feature of Buxton for many years and Sir Joseph Paxton and others did much to enhance the appearance of the Slopes by planting trees, shrubs and providing pleasant walks. Paxton's modifications of the 1840s resulted in changing the design of Wyatville's scheme.

Visitors were accommodated in a number of places, including the Hall, 'The George', 'The Eagle', 'The Queen's Head', and, of course, the Crescent. Those who came after 1852 could read the 'Buxton Advertiser' newspaper, which made its début in July of that year, priced at one penny. It has been published regularly since 1852 with small changes to the title in 1951, 1959 and 1974.

Broadwalk was designed by Sir Joseph Paxton in the 1850s as villa homes for the local gentry. Initially, this pleasant thoroughfare was named Cavendish Terrace in memory of the family name of the Duke of Devonshire who funded the building project. The steady influx of tourists in the mid-19th century encouraged the redesigning of the Natural Baths between 1851 and 1856. A double public pump was built around this period in 1853, supplying both natural thermal and cold water.

As Buxton moved into the 1860s several important developments took place. The coming of

Opposite:
'the Picture House' was built in 1916 and replaced by 'The Spa' cinema in 1937. Looking at this view of 'The Picture House' can leave little doubt that Harold Lloyd is the main attraction.

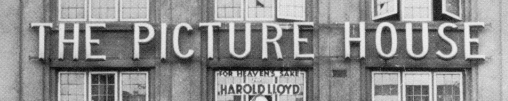

THE PICTURE HOUSE

CONTINUOUS PERFORMANCE

SHOWING TO-DAY

FOR HEAVEN'S SAKE
Starring HAROLD LLOYD

HAROLD LLOYD
FOR HEAVEN'S SAKE

TO-DAY

HAROLD LLOYD

the railways to the town encouraged visitors and made commuting more viable between the spa town and Manchester. In the light of this, hoteliers began sprucing up their premises, with the Palace Hotel constructed in 1876-78. Holiday-makers could now travel from Manchester and enjoy a comfortable sojourn at the Palace which was conveniently located adjacent to the railway station.

Milner's famous iron and glass Pavilion dates from 1871 and offered added attractions for the growing number of visitors. Five years later a Concert Hall was constructed at the end of the Pavilion, providing accommodation for 1,000 people who now could enjoy gardens which had been laid out along the banks of the River Wye.

Perhaps one of the most memorable events in the late 19th century was the addition of a huge slate dome to the Devonshire Hospital in 1880. Locals and visitors alike were amazed by the 154 foot span. It was larger than the dome of St. Paul's Cathedral, London, and at the time was the biggest unsupported dome in the world. Naturally, it proved to be quite a tourist attraction.

1889 brought the completion of Buxton Town Hall, built in stone from local quarries. Occupying a prominent site at the top of St. Ann's Cliff, this civic building took two years to erect.

Access to the area was further improved in 1899 with the inauguration of the LNWR branch from Ashbourne. In addition to providing the company with a means of running services from Euston to Manchester, the move increased Buxton's tourist traffic.

In the next decade a new Pump Room was opened in 1894 in front of the Crescent, with the eighth Duke and Duchess of Devonshire officiating at the ceremony. A new public pump replaced the 1852 double pump which supplied both warm and cold waters.

The Twentieth Century

During the mid-1890s the spa town became an Urban District Council, superseding the Local Board which had run Buxton's affairs since 1859. Queen Victoria graced the town with her presence in 1899 and Buxton entered the 20th century as a thriving holiday resort and popular spa where plush hotels and hydros tempted people to come and sample the waters. The rebuilding of the Thermal Baths took place in 1900, and three years later the Opera House began business with its capacity for an audience of 1,250 people.

Royalty visited the town once more in 1905 when King Edward VII paid a visit. During the two world wars Buxton hospital and hotels were used to nurse injured troops. A legacy of this is the Toboggan Run close to the Cavendish Golf Links, constructed by Canadian troops who were based in the town following the 1914-18 War. In the period after World War One the spa

town became well known as a conference centre, but this was curtailed with the outbreak of World War Two. It was about this period that the Natural Baths were refurbished, with the town's cinema, constructed in 1916, being rebuilt in 1937. Older residents will remember the former 'Picture House' with its distinctive verandah which extended round the side of the cinema and up Holker Road.

Unfortunately, post war years brought a decline in the number of people taking the waters, leading to the demise of the Devonshire Royal Hospital annexe (the Clinic). Its doors were closed in 1963 and the Thermal Baths ceased business the following year. However, the Natural Baths carried on until 1972 when the swimming pool in the Pavilion Gardens was opened. It is here that today's visitors and residents may enjoy a dip in the warm spa waters.

The Waters Today

The source of the spa water can be observed in the Tourist Information Centre, which once served as the Natural Baths building. This housed the public baths until 1976 when the swimming pool opened in the Pavilion Gardens. As we have seen, the only way to sample the waters now is to use the public well close to the Micrarium (the former Pump Room) or have a dip in the swimming pool.

Interestingly, the water comes from a spring and maintains its temperature of 81.5°F no matter what time of year! It would appear that the length of time spent underground together with the great depth account for the constant 27.5°C. It seems probable that rain falling to the east of Buxton seeps into the limestone and is forced to the surface by hydrostatic pressure. A fault line allows this to happen and the resulting spring water contains a number of constituents, including carbonate, calcium, chloride and sodium, together with traces of magnesium, potassium and nitrates.

Initially, people either bathed in the waters or drank them, and in the 1800s a number of new alternatives were provided. These included douches, Turkish baths, sand baths or even immersion in peat brought in from local moorland!

There was some consternation in spring 1989 when a national newspaper suggested St. Ann's Well had been shut down by health officials. It was claimed they were checking the nitrate and fertiliser levels in the water. Buxton Mineral Water Company and High Peak Borough Council quickly issued a joint statement saying the well was not closed because of any health hazards.

In fact, the water supply to the well was shut off to facilitate routine maintenance work to be carried out in the pump room of the old Buxton baths. This involved maintenance of pipes leading to Mineral Water Company's processing plant. The procedure is carried out annually

and requires the plant to be shut down for a short period. Naturally, the well still functions as usual and it allows people to freely try the waters.

Buxton is a dignified town whose pleasant shops, stately buildings and impressive amenities make it an enjoyable place to visit. Annual events include the International Festival in July and August and a Summer Carnival. There are also numerous antique, book and collector's fairs, together with well dressing ceremonies. These usually take place in the second week in July when three wells are dressed.

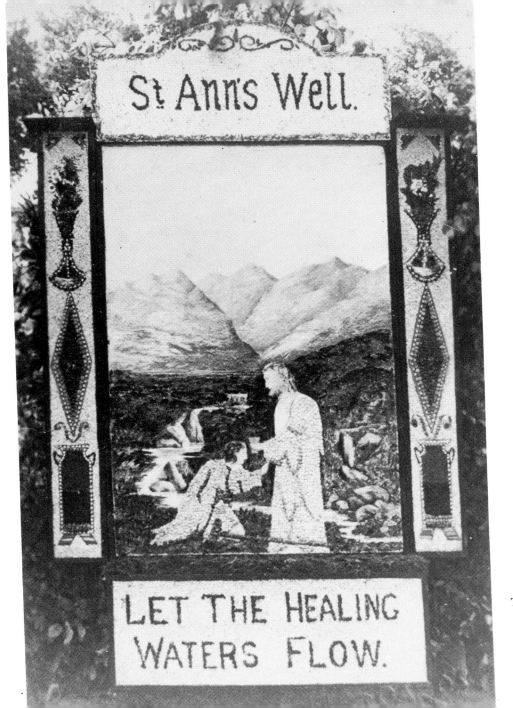

Three wells are dressed in Buxton during July.

Chapter 2: Architectural Heritage

Buxton offers an interesting architectural past. For instance, a Roman fort more than likely occupied a site at Silverlands, while the remains of Roman baths have been discovered beneath the Crescent buildings. Of course, the real development of the town began about 1780 when the fifth Duke of Devonshire introduced his ambitious planning schemes. We have already seen that the arrival of the railways in the 1860s encouraged several building programmes such as the Palace Hotel and the Pavilion Gardens.

A stroll around the town today reveals a legacy of gracious buildings ranging from the Edwardian Opera House to the Devonshire Royal Hospital.

The Crescent

Buxton's largest building was constructed by order of the fifth Duke of Devonshire between 1780 and 1788. He had negotiated terms with architect John Carr who was asked to design an impressive hotel in the shape of a crescent. This was intended to compete with James Wood's building in Bath, the shape of the Crescent being determined by the curve in Buxton's River Wye.

To prepare the foundations, trees in the Grove were felled and the Mount levelled. During the work a rectangular-shaped Roman bath was unearthed, measuring 15 feet in width and 24 feet in length. It was fed by a lukewarm spring and a floodgate allowed water to leave at the east end of the bath.

Materials for the Crescent were transported from a number of local quarries, including those at Buxton, Matlock, Bakewell Edge, Chinley and Youlgreave. Owing to a dearth of timber, much of the wood had to be imported at Hull and then carried by barges along the Rivers Humber and Trent.

Interestingly, the Crescent features three storeys at the front and four at the rear. It contained the Duke's town house in the centre, more dwellings at the east end and St. Ann's Hotel at the west of the structure.

Designed in the Doric style, the Crescent has several narrow entrance halls opening into the Arcade, while the Cavendish coat-of-arms is set in the balustrade. The magnificent structure was intended to be divided into three hotels - the Grand, the Crescent and St. Ann's. Each had its own private entrance to the shops and banks along the arcaded ground floor.

Try and visit Buxton Library, which occupies what was once the Crescent's Assembly Rooms. These were also employed as a hospital and the venue for church services. The fine Adam-style ceiling can still be admired in this corner of the Crescent.

Opposite:
The ducal arms are set in the balustrade of the gracious building.

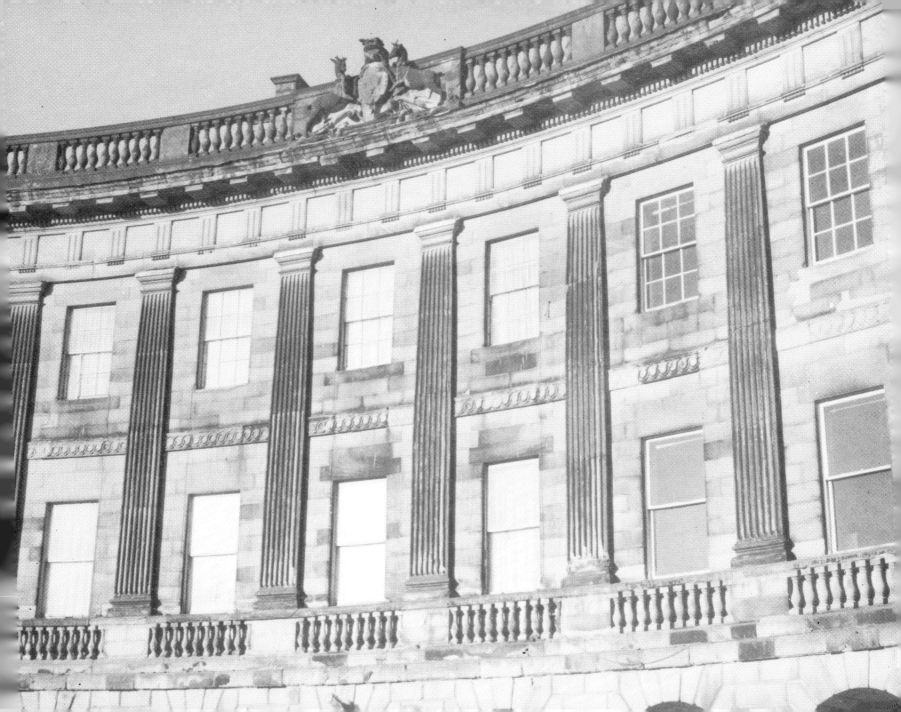

Those who appreciate Georgian architecture will compare and contrast the Crescent with John Wood's building in Bath. However, the Buxton structure is rather hollow in appearance since a local landowner would not permit the Duke to buy a more impressive site. Nevertheless, one ought to applaud the thinking behind the scheme. Built at a time when only some 600 people permanently resided in the spa town, the Crescent is truly one of northern England's most impressive Georgian town buildings, and stands as a testimony to the skill of the architect, John Carr.

The Town Hall

The principle side of the Town Hall faces the Market Place. Built in 1887-89 and designed by W. Pollard of Manchester, the structure overlooks the Slopes, the weather station and the War Memorial. The Town Hall, costing £12,000, was built by a local man who used materials from a quarry at nearby Corbar.

The Devonshire Royal Hospital

The Duke of Devonshire and his architect John Carr followed the construction of the Crescent with the building of large stables, just to the north, in 1790. Since there was no provision for houses, grooms or carriages in the Crescent, the Great Stables were begun in 1789 at a cost of £16,470.

Somewhat unusual in design, the structure was circular on the interior and octagonal on the outside. The inside circle measured 180 feet in diameter with a colonnade which permitted people to ride under cover if the weather was wet.

One hundred and thirty horses could be stabled in the building together with carriages, while apartments offered roomy accommodation on the upper sections for grooms and servants.

In 1857 a section of the stabling block and surrounding land was given over as a hospital following an agreement with the sixth Duke of Devonshire. Opening in 1859, the hospital treated patients suffering from rheumatism, and during the Cotton Famine, a large number of destitute women were sent there. Why was this? Well, the outbreak of the American Civil War in 1861 had a deleterious effect on the Lancashire cotton industry. Supplies of Southern raw cotton were blockaded by the North and a slump followed. The ensuing hardship for Lancashire mill workers encouraged the establishment of a Cotton Famine Relief Fund, and money raised was used to send young women to convalescence places in the winter of 1862-63. One hundred of these people were accommodated in the Hospital at Buxton.

It was in 1878 that the Duke of Devonshire allowed the building to be given over entirely for

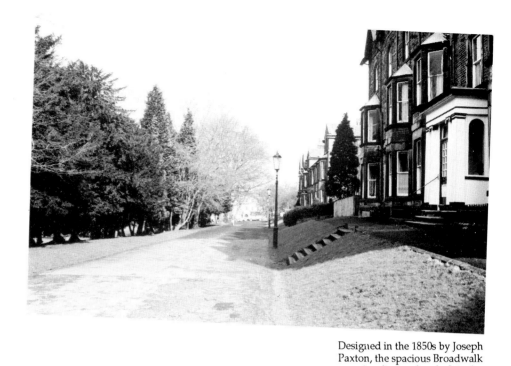

Designed in the 1850s by Joseph Paxton, the spacious Broadwalk contains discreet hotels. It is the ideal place to take a quiet perambulation alongside the Pavilion Gardens.

When staying at the original Old Hall, Mary, Queen of Scots scratched a message on a window.

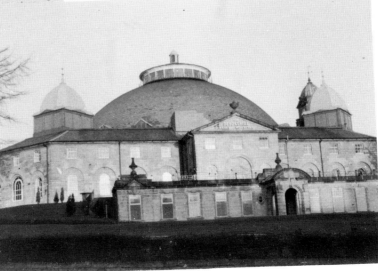

In 1881-82 the Devonshire Royal Hospital received its massive dome, angle turrets and clock tower.

21

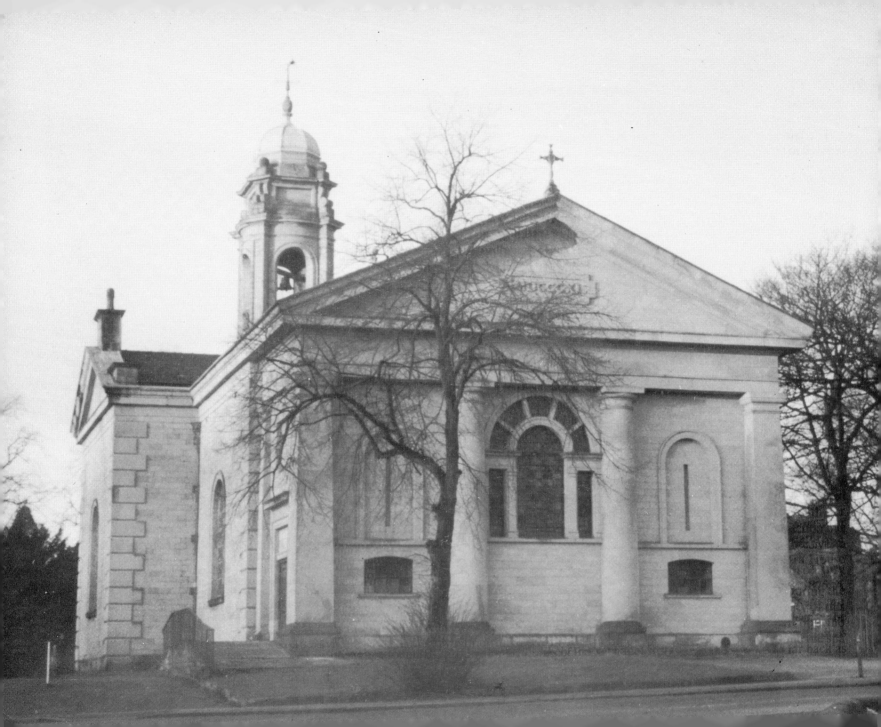

hospital purposes. This necessitated a number of alterations, including demolishing two internal walls which ran round the building, while a new concrete gallery gave easier access to upstairs wards.

The famous slate dome was added in 1880, measuring about 150 feet in diameter and reputed to be bigger than the one at St. Peter's, Rome. Built to cover the courtyard of what was a riding and exercise area, the dome could house 6,000 people in its half-acre site. New mineral water baths were built in 1914 on the south front of the hospital. Seven years later, the Princess Royal (then Princess Mary) laid the commemoration stone of a new hospital wing. King George V gave permission for it to be called a 'Royal' hospital in 1934, and under the provisions of the National Health Act (1946) the hospital was taken over by the Minister of Health in 1948.

Today's Royal Devonshire Hospital comes under the auspices of Stockport Health Authority and has 165 beds divided between Physical Medicine, Rheumatology and Orthopaedic Surgery.

The Old Hall

Erected in 1572-73 by the sixth Earl of Shrewsbury and offering reasonable accommodation for guests, the Hall was four storeys high and could sleep 30 people. We have seen in Chapter 1 that Mary, Queen of Scots stayed here while she took the waters. This lady will never be forgotten while the place stands.

John Speed's map of 1610 provides the earliest known picture of Buxton, showing the Hall and St. Anne's (spelt with an 'e' at the time) Well as separate buildings.

During the disastrous fire of 1670 the place was destroyed and a larger building constructed on the same spot by the third Earl of Devonshire. There followed more improvements by landlord Cornelius White in 1895-96, including repairs to the old bath and a new one was supplied for use by poor people. While digging the drains, Mr White uncovered a Roman bath.

In spite of the 17th century modifications, some guests did not approve of the place. Celia Fiennes, a famous intrepid lady traveller in the late 17th century, commented in 1687:

'The house that's called Buxton Hall, which belongs to the Duke of Devonshire, it's where the warme bath is and well; it's the largest house in the place though not very good... Few people stay above 2 or 3 nights, it's so inconvenient. There is no peace nor quiet with one company and another going into the bath or coming out... the beer they allow at the meales is so bad that very little can be dranke.'

The facilities must have improved, however, since in 1745 the Reverend John Nixon FRS, stayed at the Hall and was:

'.. .greatly exhilarated by the agreeable company we found in it, which consisted of about 40 or

Opposite:
A tribute to a John White design, St. John's Church was completed in 1811, with considerable alterations taking place in 1897-98.

50 ladies and gentlemen... eating at one common table and conversing together promiscuously with the greatest freedom and affability imaginable.'

Records indicate that the Hall was the most pleasant place to stay in Buxton until the Crescent was constructed. It was not until the mid-19th century that it was known as the Old Hall.

Today's Old Hall Hotel occupies a central location overlooking the Pavilion Gardens and the Slopes. Impressive facilities in the recently refurbished hotel include 40 modern bedrooms, restaurants and Mary's Wine Bar, with excellent conference facilities provided in the Decameron Room and Shrewsbury Suite.

Drama facilities are available in the Pauper's Pit - so named to commemorate the Poor Bath, a tiled hollow exposed to the elements on one side and located in the yard.

Perhaps the highest accolade to the Old Hall Hotel in recent times was paid in early 1989. Hotelier Louise Potter, who runs the hotel with her husband, was one of six finalists selected from nearly 350 entrants nationwide in a women's enterprise award scheme. Mrs Potter finished runner-up in the contest, the judges saying she showed great business acumen and shrewdness.

Broadwalk

Designed by Sir Joseph Paxton in the 1850s as villa homes for the local gentry, Broadwalk was initially called Cavendish Terrace, after the family name of the Duke of Devonshire who funded the building.

The traffic-free area features pleasant hotels which front onto the Pavilion Gardens - a tranquil spot where locals and tourists alike can savour the idyllic atmosphere of this tree-lined backwater.

The Parish Church

Finished in 1811, St. John the Baptist is more than likely the work of John White. The eastern portico of large columns was closed in during 1897 and the rather plain tower features a domed top.

St John the Baptist is essentially a late Georgian Italianate church with ornate 19th century embellishments - for instance, the pulpit dates from 1867, and the font can be traced to 1875. A look inside will reveal that the church lacks aisles but has shallow transepts. There are examples of stained glass and some fine mosaics in the Chancel. The two north windows are the work of Kempe, decorated with classical motifs. In spring 1989 the place of worship was the venue for a BBC production of 'Songs of Praise'.

St. Anne's Church

Hiding just off High Street, this small place is well worth a visit. The date over the north porch reads 1625, although a curate held office as far back as 1608. The tiny church is only 19 yards long and 7 yards wide and does not possess a tower.

There are no aisles and the low beams are only eight feet or so above ground level. Some people would claim this to be the oldest building in Buxton, and it certainly has a varied history, having served as a school room, barn and, of course, a church.

Originally, the church was dedicated to St. John in order to suppress the worship of St. Anne whose curative powers were associated with Buxton's waters, but soon the name of St. John gave way to that of his female counterpart.

Because of the lack of space at St. Anne's, services were moved to the Assembly Room in 1798, which had opened ten years earlier. On completion of the Church of St. John the Baptist, St. Anne's ceased to be the Parish Church. In 1813 the building was being used as a school-room.

The Market Cross

Thought to date from the 15th century, the cross originally occupied a spot on Cockyard Hill, near the site of the Palace Hotel. It was moved in 1813 when a market charter was granted.

St. Anne's Well

Known locally as St. Ann's Well, the drinking fountain in the Crescent is a Buxton landmark where people can sample the pale blue water. Roman soldiers are known to have bathed in this warm thermal spring. The links with St. Ann are obscure (see Chapter 1), but by the 16th century the saint had become associated with the well and its curative waters. In fact, 15th century documents mentioned a 'Halywell' or Holy Well.

For many years pilgrims visited the well until Henry VIII's commissioner stopped what he called superstition and idolatry and closed the shrine (see Chapter 1). This régime lasted only until the mid-1500s when the chapel and well became operational once more. It was about this period that the Coterell family showed an interest not only in the well and chapel but also in providing accommodation for those who came to take the waters at the well.

The link between Buxton and Mary, Queen of Scots has already been mentioned in connection with the Old Hall Hotel. She first came to the town in 1573, visiting St. Ann's Well when seeking a cure for rheumatism.

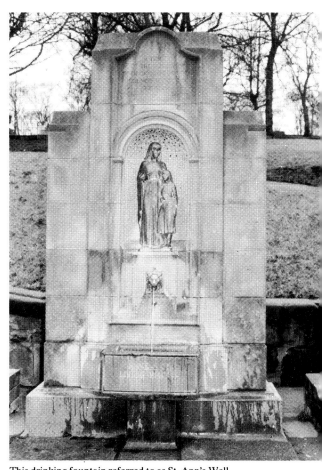

This drinking fountain referred to as St. Ann's Well, was given to the town in 1940. The free source of warm, blue water is adjacent to the Micrarium, and springs supplying the water are thought to originate from 5,000 feet below ground!

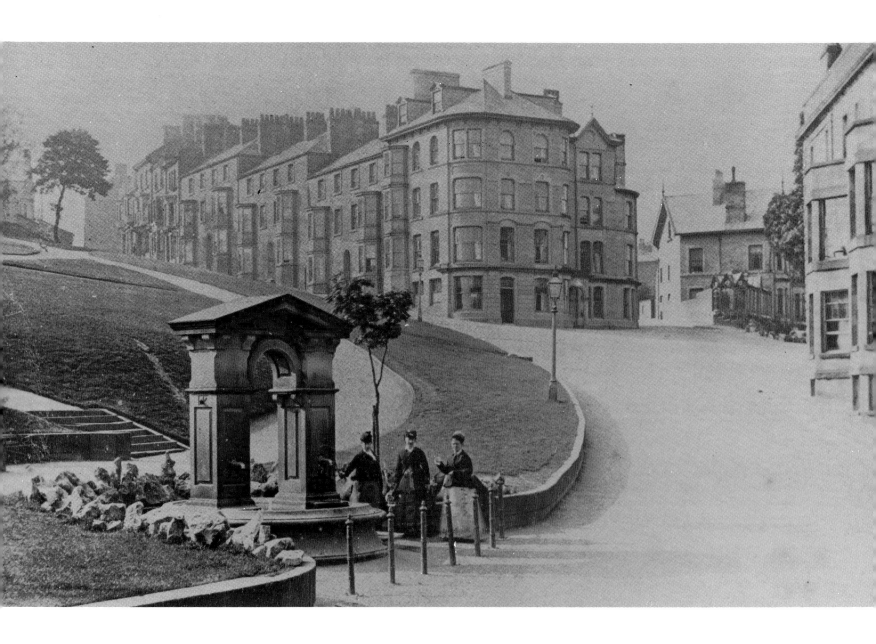

Speed's map of 1610 tells us that the well was some 60 yards from the Hall. A century later, Sir Thomas Delves from Cheshire built a stone alcove over the spring in the yard of the Hall. The 12 foot square structure contained stone seats for people who drank the waters which bubbled into a basin.

During the building of the Crescent it became necessary to move the well from its original spot and resite it at the foot of St. Ann's Cliff. The new structure measured 15 feet square and was surmounted by a crowning urn on completion in 1783. Once the polishing of the marble basin was complete, spring water was piped from the site of the old well, and no fee was levied for drinking the waters.

Older Buxton folk will remember that in 1940 the free pump was replaced by today's model, adjacent to the Micrarium. Carrying the words 'Well of living water', it is dedicated to a councillor of the borough, Emilie Dorothy Bounds.

The Slopes

Formerly known as St. Ann's Cliff, this hilly spot offers commanding views of Buxton. These are best enjoyed before dense foliage on trees obscures a scene featuring the Crescent, Opera House and the Devonshire Royal Hospital.

The Crescent was built at the foot of St. Ann's Cliff which at the time was a rather forlorn looking hillside. However, when trees in the Grove gardens were felled to make way for the Crescent, the Cliff was landscaped. Now locals and tourists could enjoy pleasant walks in an area surrounded by a new wall with access through iron gates. The foot of the Cliff was illuminated by three lamps mounted on tall supports, their main function being to light the forecourt of the Crescent. The lamps were replaced in the 19th century.

1818 saw the construction of the Serpentine Walks and landscaping of St. Ann's Cliff's by Sir Jeffrey Wyatville. The resulting verdant scene attracted many people who enjoyed strolling along the gentle paths. Modifications to the hillside were carried out during the 1840s by Sir Joseph Paxton, a man renowned for his work on London's Crystal Palace.

A stroll to the summit of the Slopes today will reveal a small weather station, war memorial and the Town Hall. The period between 1989 and 1992 will see the removal of many trees from the Slopes as part of environmental improvements. It is thought that taking away a substantial proportion of trees is essential for conservation purposes. By 1992 the town centre hillside should have reverted to the Victorian Gardens it once was. This will entail renovating the war memorial and urns, rebuilding walls, relaying paths and creating new flower beds.

Opposite:
A glimpse of the Crescent and the roof of the former Pump Room from the Slopes.

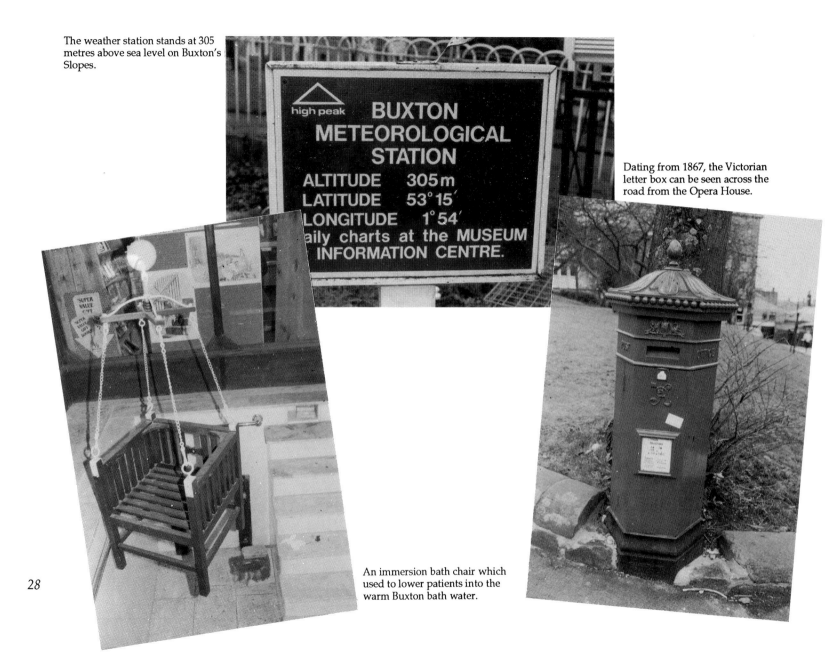

The weather station stands at 305 metres above sea level on Buxton's Slopes.

high peak

BUXTON METEOROLOGICAL STATION

ALTITUDE 305m
LATITUDE 53°15′
LONGITUDE 1°54′
aily charts at the MUSEUM INFORMATION CENTRE.

Dating from 1867, the Victorian letter box can be seen across the road from the Opera House.

An immersion bath chair which used to lower patients into the warm Buxton bath water.

Victorian Letter Box

How many people leaving the Opera House have bothered to glance across the road as they leave the building? If they did this, theatre-goers would see a Victorian letter box, unique in Derbyshire. The hexagonal piece of street furniture dates from 1867 and features the cypher of Queen Victoria.

The Natural Baths and Thermal Baths

In 1818 one Mr Sylvester was responsible for some marble baths used for warm bathing, which could be found at the eastern end of the Crescent. The warm bath received water from the Natural baths whose water was heated by steam.

The Natural baths were rebuilt in 1851-1856 by Henry Currey and modernised in 1924 when there was one swimming bath for ladies and two for men. Further developments followed in 1937 with £20,000 being spent on rebuilding the Natural baths, but this did not seem to encourage more visitors. In fact, following World War Two spa treatment declined and so the Natural baths were used as a swimming pool until 1972 when the new facilities opened in the Pavilion Gardens. The former Natural baths building is now the home of the Tourist Information Centre.

The Thermal baths were found at the other end of the Crescent, fed by natural springs which flowed into a reservoir from where water was pumped inside the building. These baths had an arcaded front and were more than likely the result of co-operation between Messrs Currey and Paxton. The glazed roof was taken off when the eighth Duke of Devonshire rebuilt the Thermal baths in 1900. Buxton Corporation carried out more work in 1912, including considerable tiling to the interior.

The elegant iron veranda was removed in the mid-1960s when the baths closed. Today the premises of the old Thermal baths have been redeveloped into an attractive shopping arcade where one can still see reminders of how things used to be. For instance, the chair on display was employed to lower patients into an immersion bath.

So much for the history and development of the Natural and Thermal baths, but what about the treatment on offer? Bathers were given the opportunity to try both facilities, walking under cover along the Crescent's colonnade which linked the Natural baths to the warm ones.

Visitors availed themselves of shower, douche and vapour treatment, while natural and chalybeate waters could be consumed in the Natural baths. The douche treatment was offered in either dry or wet form, the first method involving spraying a person who sat or lay in an empty bath. The wet douche was a similar experience, only this time the patient was immersed in water.

To discover more of the treatment on offer, have a browse round the shopping arcade where to Thermal baths were situated. A number of plaques on the wall remind us of treatment that was on offer in the heyday of the baths. The list includes the following:

	Shillings	Pennies
Needle douche	2	6
Needle douche with immersion bath	3	6
Douche massage	4	0
Facial massage with sprays	3	6
Moor pack and immersion	3	6

The last item on this extract was encouraged by the abundance of peat found in local moorland. After soaking in water, the peat was mixed into a paste. A person spent between 15 and 45 minutes covered in this mixture after which a warm bath removed all traces of the peat! Some visitors found this a useful cure for rheumatism, and if this did not work there was always a Turkish bath available.

Happily, the days of the Thermal baths will not be forgotten. Buxton could have a living museum of the famous baths and spring water by the mid-1990s. Plans to re-open the Natural baths as a health centre have also been considered. The new centre, known as Buxton Thermal Springs, would be located in the present Natural baths buildings, which we have seen, dates from 1851 and was closed to the public some 20 years ago.

People would enter from the courtyard at the rear, and in this ambitious plan for the 1990s, the centre would also provide videos and displays showing the history of Buxton and its waters, complete with actual springs and baths containing water.

This man is undergoing a gruelling session in a Douche Bath at the Thermal Baths.

Opposite:
A typical Christmas postcard scene in Buxton's Pavilion Gardens. The land along the bank of the River Wye was given by the seventh Duke of Devonshire, while the ornamental gardens were designed by Edward Milner.

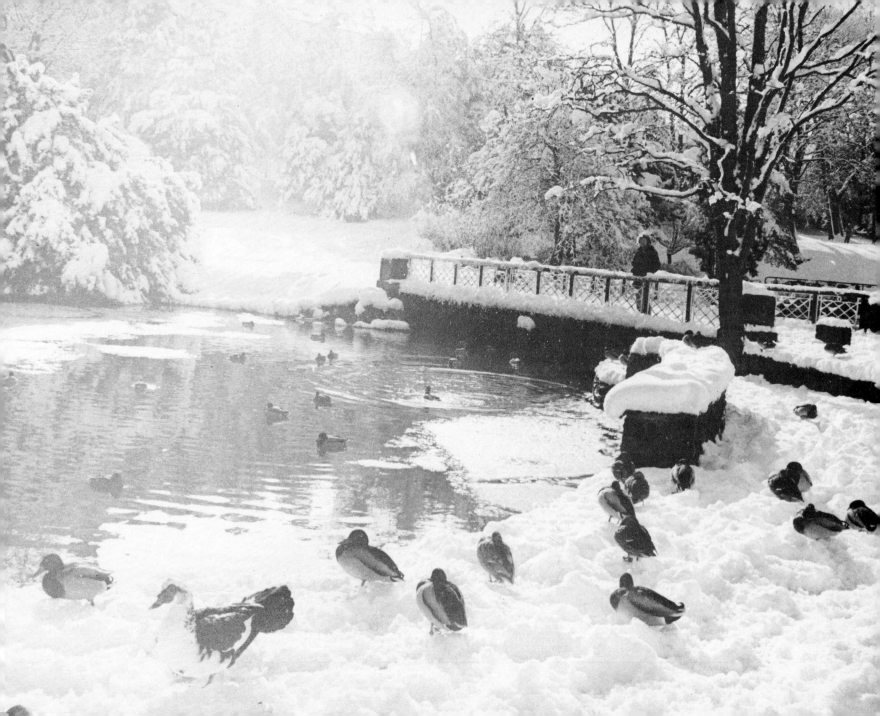

Chapter 3: Leisure and Pleasure

Buxton offers something for everyone - behind the Crescent one discovers the Pavilion, Opera House and Pavilion Gardens, and a stroll down Spring Gardens, the main shopping street, is recommended. For a more leisurely activity why not browse in the Museum and Art Gallery or examine the Micrarium where visitors can examine natural life through microscope.

The abundance of tea rooms, pleasant gardens and relaxed way of life all contribute to an enjoyable visit to Buxton.

The Pavilion Gardens

The coming of the railways in the 1860s encouraged development in Buxton with the Palace Hotel built close to the stations in 1868. The 23 acres of the Pavilion Gardens were laid out on land along the banks of the River Wye which was given by the seventh Duke of Devonshire. Tasteful ornamental gardens were designed by Edward Milner and they provide smooth lawns, quiet walks, a miniature railway, paddling pool and a playground for children.

Just to the west of the gardens the River Wye flows gently between wooded banks in an area called the Serpentine Walks where there are riverside seats and pleasant trees and shrubs. This area was landscaped by Sir Joseph Paxton and others in the 19th century.

The Pavilion itself is an elegant glass and iron structure by Edward Milner, completed in 1871, providing shelter in poor weather. Four years later the octagonal concert hall was added, the work of R.R. Duke who also covered the stables with the huge 156 foot dome. As we have seen above, the Swimming Baths were built between 1969-72.

The Pavilion Gardens and their amenities have long been one of Buxton's principle attractions, with walks, a conservatory, restaurants, book fairs and live bands providing rich and varied entertainment. The beauty of this part of Buxton reflects the efforts of gardeners who obviously adhere to Voltaire's advice in 'Candide' - 'Il faut cultiver notre jardin'.

Woods and Dales

Ashwood Dale has at its Buxton end, Ashwood Park featuring tennis courts, putting green, walks and gardens. The nearby Sherbrook Dell contains a large natural cleft in the limestone known as Lover's Leap. The upper end of Sherbrook Dell joins Duke's Drive, built in 1795 by the Duke of Devonshire.

Grin Low Woods is situated just behind Poole's Cavern. The 100 acres of woodland - Grin Low Woods, Buxton Country Park - hide an ugly ash tip, caused by burning limestone to make lime in the 17th and 18th centuries. The woodland was planted around 1821.

The River Wye snakes its way through Ashwood
Park.

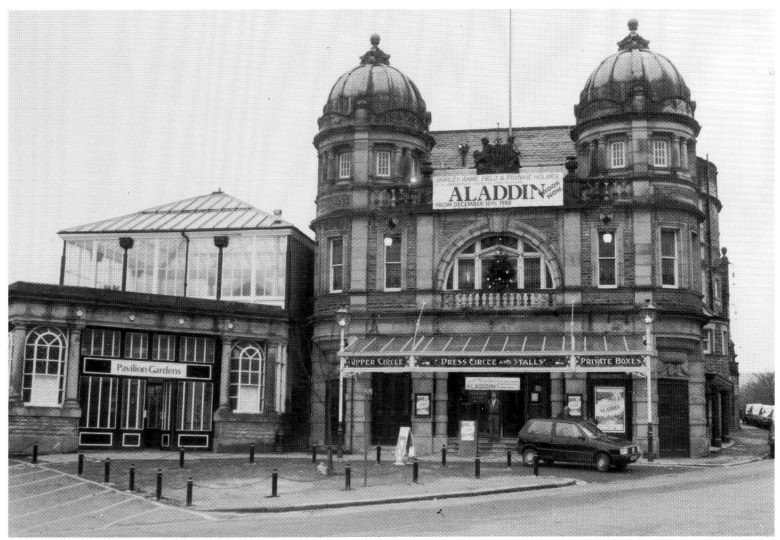

Designed by Frank Matcham, the Opera House was
opened in 1903 and is the focal point for the annual
Buxton Festival.

The folly, Solomon's Temple, takes its name from Solomon Mycock who, in the 1890s, built this structure from where panoramic views can be enjoyed, at 1440 feet above sea level.

Spring 1989 saw the completion of a ten-year, multi-million pound investment in restoring Grin Low. The quarry was bought by the County Council in 1979 and restored with the aid of a derelict land reclamation grant. Visitors can now enjoy an up-market camping and caravan site, and a residential hostel. 1989 brought the opening of the final phase of the scheme which included an information centre, toilet block and a new ranger post.

Corbar Woods, occupying a site just off the Long Hill Road on the north of Buxton, afford splendid views of the town and its environs. Corbar Cross was erected in 1950 to commemorate the Catholic Jubilee Year, and from its position of 1433 feet above sea level there are magnificent views. Winter visitors may wish to cross the Long Hill Road, just north of a caravan site, in order to reach the toboggan run. This is above the Cavendish golf links and was made by Canadian troops, staying in Buxton after the First World War. There is also a similar run at the top of College Road, not far from Grin Low Woods.

The Theatre and Cinema

A theatre occupied a spot in Spring Gardens as far back as the 18th century. A more up-to-date one began performances in 1833 on Hall Bank. This was demolished in the 1850s. Towards the close of the 19th century it became clear that a more spacious theatre was required to accommodate the increasing number of visitors to the spa town, and so one began business next to the Pavilion in 1889.

In 1901 the Buxton Gardens Company employed architect Frank Matchum to build a larger theatre, and so two years later the Buxton Opera House started entertaining the public. Seating 1,200 people, its interior was the work of a London-based firm called Dejong Company.

The Opera House of 1903, curiously featured both gas lighting systems and wiring for electricity. The centre of the auditorium ceiling had a gas fired 'sunburner' which was dismantled and adapted for North Sea gas in more recent times.

A cinema projection box was installed in the early 1930s in an attempt to fill seats at a time when the cinema industry was making its impact on theatres up and down the country. Ironically a former cinema was reopened as the Playhouse Theatre. The year 1937 brought the first of several popular theatre festivals which ran until World War II.

In the years following the War the Opera House still functioned as a cinema but it gradually fell into disrepair, much to the chagrin of theatre-goers who were determined to renovate this architectural gem. Consequently, a trust was set up to restore the place as a theatre. Following

careful planning and hard work by a number of companies, the Opera House was refurbished at a cost of £504,488 in 1979, in time for the first Buxton Festival.

A new orchestra pit was created for 85 players, electrical installations were renewed and modern lightly appeared throughout the theatre. Today's colour scheme of cream, brown, blue, gold and white is similar to the one enjoyed by Edwardians who attended performances in the early 1900s. Modern productions range from drama and pantomime to Jazz concerts and Carol concerts, with famous national and international stars gracing the stage.

The Opera House is, of course, the focal point for the annual Buxton Festival held at the end of July and the beginning of August. Ten years after its rebirth, this stately building looks like having a long and successful future, encouraged by a number of schemes including one launched in 1989 whereby sponsors had their names inscribed on seats. This was recorded on a seating plan displayed in the Opera House foyer. Sponsors have also been given honorary membership of the Friends of Buxton Opera House, entitling them to priority bookings and discounts at certain productions.

The Hippodrome was popular with cinema audiences in the early 1900s. Located close to the Pavilion, it began showing silent films in 1904.

The Spa Cinema, Spring Gardens opened its doors in 1916 and was rebuilt in 1937. However, the popularity of television led to its closure in the early 1970s, and after a brief spell as a bingo hall and cinema in the 1980s, the Spa was pulled down in 1987.

The Museum and Art Gallery

Arrangements were made for a free public library in 1889, and two years later it was decided to incorporate a museum. Both moved to the Peak Buildings in 1928, but when Derbyshire County Council took over the running of the museum and library, the latter was transferred to the east wing of the Crescent.

Today's Buxton museum is housed in a building once serving as the Peak Hydropathic Hotel. Visitors may be interested in the wide variety of exhibitions which include prehistoric remains from local caves. There are also geological collections, together with manuscripts belonging to experts in archaeology and cave prehistory.

The Art Gallery, which opened its doors to the public in 1979, provides a wide range of contemporary art. If possible, try to visit the gallery during the International Buxton Festival (late July/early August) when a superb exhibition is on display.

The Micrarium

Located directly opposite the Crescent, the Micrarium building has an interesting history. The

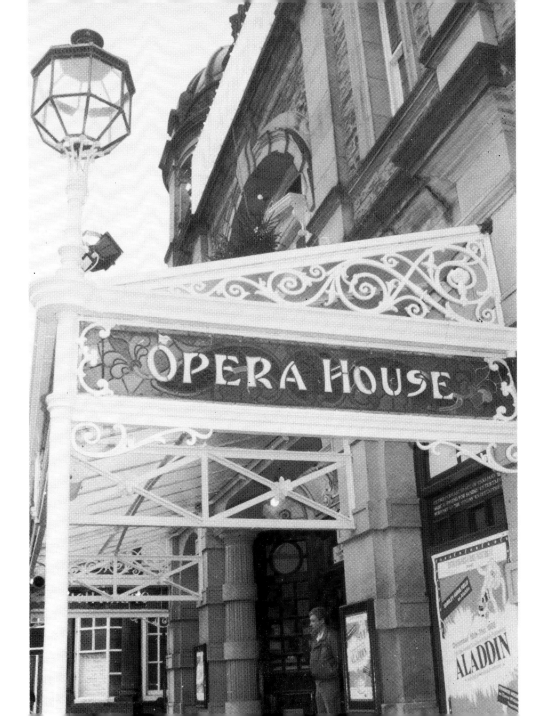

The Opera House was lovingly restored in 1979. The intimate theatre has seating for 85 musicians and an audience of 946 people.

38

Pump Room was built in 1894 as part of the spa treatment, and visitors were offered tepid and chalybeate waters. Designed by Henry Currey, the Pump Room initially featured open arcades but these were enclosed in 1911-12 when domes were removed from the end pavilions of the building. Thermal water was served here until 1981, but today it houses a private museum, the Micrarium.

Well worth a visit, the Micrarium opens up the immense wonderland of 'Inner Space' and makes it accessible to everyone. Specimens on display encompass the whole spectrum of the Natural World - animal, vegetable and mineral, and everything in the Micrarium is real - no photographs or ciné films here!

Instead there is fun for all the family who can explore the fascinating world of nature through specially built projection microscopes. Do not be deterred if you have never used a microscope before - there is no need to peer down a narrow tube. Instead, microscopes project onto TV-size screens, and by simply pressing buttons, hundreds of microscopic objects are automatically presented to amaze and delight you.

Poole's Cavern

If you wish to go to Poole's Cavern on foot why not meander through the Pavilion Gardens, or amble along Broad Walk until you come to the large road junction at College Road. Cross the main road, proceed up Temple Road, following the signs for Poole's cavern - a mere three quarters of a mile from the Crescent.

What is the Cavern and who was Poole? The place is basically a large cave in Grin Low hill and is said to take its name from an outlaw who lived in the reign of Henry IV. Poole stored his booty there, but he was not the first inhabitant since Stone Age man lived beneath the entrance arch, and Iron Age man in the first chamber.

Under a stalagmite floor, Roman articles of pottery, tools and jewellery have been discovered. During the early 1980s further investigations unearthed Roman coins and brooches, coins from the time of Henry V, and implements used for working with metal.

So what is on view today? There are many stalactites and stalagmites in this cavern which extends for about half a mile, and their shapes have given rise to such names as the Lion, the Chair and the Font. Links with the past are also remembered by Mary, Queen of Scots' Pillar - a title given to a spot against which she is said to have leant.

Called 'The First Wonder of the Peak' in 1680 by Charles Cotton, the Cavern offers an interesting visitor's centre complete with video shows, exhibition and Roman finds from recent times.

One interesting event which occurred in Poole's Cavern was a performance by opera singer

Barbara Segal who has sung in some of the most inaccessible parts of the world. In spring 1989 she recorded some songs complete with piano accompanist and candelabra deep in Poole's Cavern.

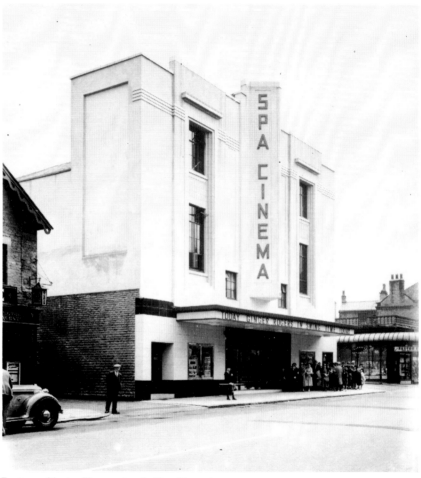

Buxton residents will remember the 'Spa Cinema' which was demolished in 1987. How many local people queued like this to see Ginger Rogers?

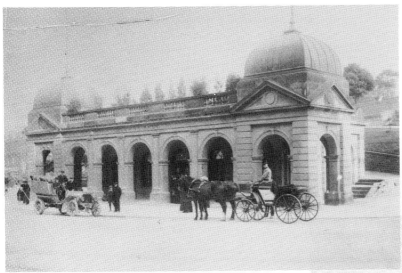

Dating from 1894, the Pump Room later became the Micrarium. This intriguing glimpse of the past depicts the Pump Room before the arcades were glazed in 1912. Two modes of transport from about 90 years ago are captured here with an early car and horse-drawn carriage facing each other.

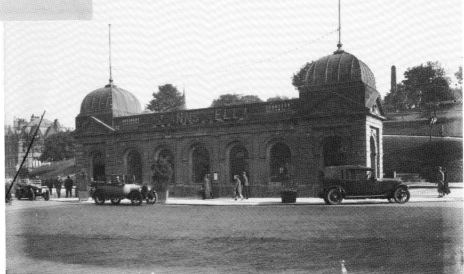

The Pump Room after the arcades were enclosed in 1912. Above the windows are the words "St. Anne's Well".

Chapter 4: Transport and Waterways

Travel has never been easy in north Derbyshire and even today roads in the Buxton area are often blocked by snow, while those in surrounding lowlands are passable. One cannot assume that the Romans made the first routes, and it is likely that some stretches were originally used in the Iron Age and then improved by the Romans. However, Roman roads did open up the Buxton area as routes came from Leek, Derby, Brough (Navio) and Glossop. Further roads ran from the west and north-west, and a Roman milestone is now preserved in Buxton Museum and Art Gallery.

The difficult terrain meant that the pack-horse was the only way of transporting goods, with local place names like Saltersford indicating the salt routes eastward from Cheshire. The steep gradients in the Buxton district prevented canal builders from constructing their waterways, and the only canals found in the area were the Peak Forest in the north, the Cromford in the south-east of the Peak District and the Macclesfield Canal on the western extremities of the region.

Buxton received the advantage of railways in 1863 when the new stations were opened, with a branch from Ashbourne coming into service in 1899. So now excursions were organised from Liverpool and Manchester and those wishing to try the waters could travel to the spa in some comfort.

Buses and Trams

The bus service linking Buxton and Macclesfield began carrying passengers in 1914, the service provided by the British Automobile Traction Company Limited, a subsidiary of B.E.T. Six years later a town service was running in Buxton, operating from a garage at Burbage. Gradually routes were introduced to neighbouring places like Ashbourne, Leek and Stockport.

Thomas Tilling Limited provided considerable assistance to B.A.T., funding a successful bus venture and, mainly to introduce Tilling capital, establishing a separate company. The North Western Road Car Company Limited, registered in April 1923, took over the Peak District and Macclesfield services. It started business with 54 vehicles.

In Buxton, a former grinding mill was purchased for a garage in Charles Street, replacing the shed in Burbage in 1926. A new depot opened in 1963, and locals will remember a North Western office in Buxton Market Place. The Buxton depot of the early 1960s had 43 vehicles ranging from Bristols to Leylands. A description of these now follows.

Bristol L single deckers. Thirteen of these operated from the Buxton depot. One bus (BJA

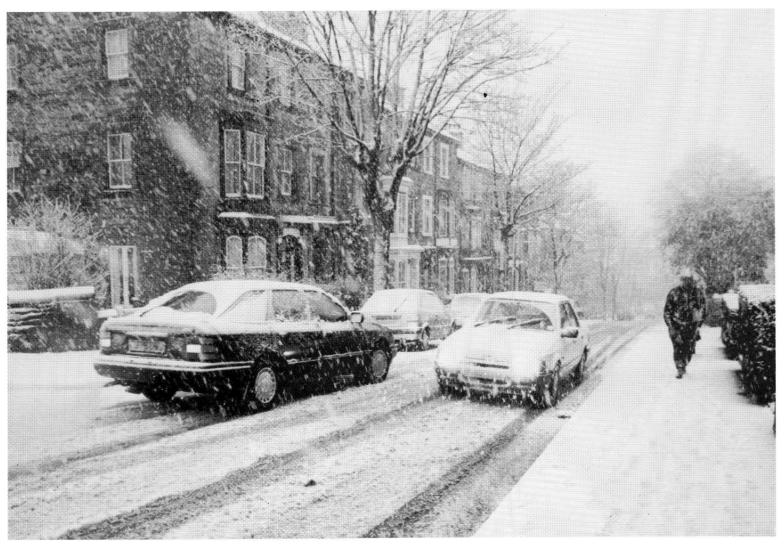

A familiar scene for Buxton residents who have to endure more than their fair share of snow-covered roads.

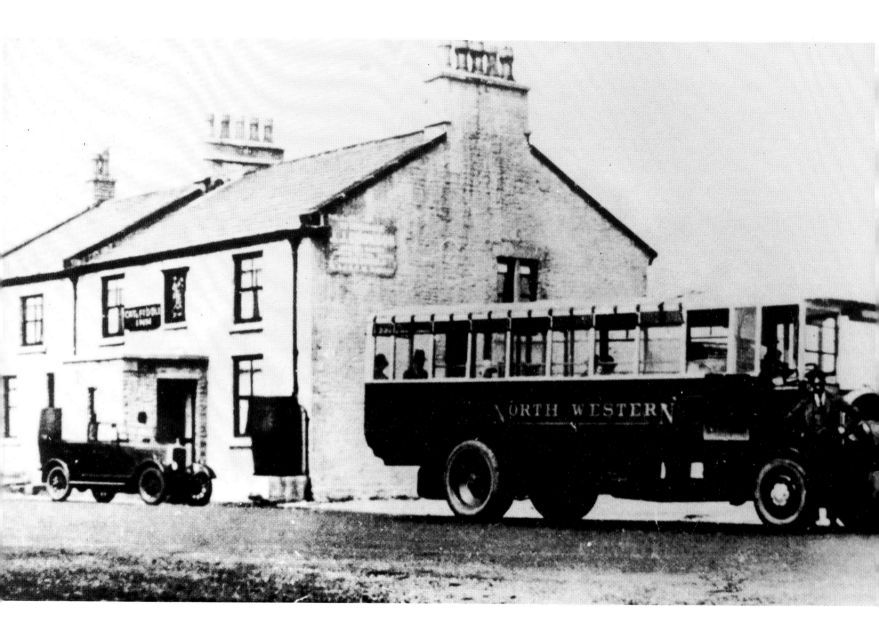

426) manufactured in 1946, was powered by a Gardner 5LW engine and carried 35 passengers. Two more Bristol Ls had similar specifications (fleet numbers 200, 201), while vehicles numbered 300, 313, 314, 315 and 320 were also powered by Gardner 5LW engines and had MCW bodywork. The remaining five Bristol Ls accommodated 35 passengers and carried Burlingham bodywork.

Leyland Tiger Cubs. Twenty-one of these served Buxton and surrounding districts. The Cubs received power from Leyland 0 350 engines, featured MCW coachwork, and were acquired between 1954 and 1957.

Dual Purpose Vehicles. Five AEC Reliances were delivered in 1958-59 with vehicles entering service in 1960. These had fleet numbers 809-811 and carried Willowbrook bodywork. The 43 seaters were driven by AEC engines.

Coaches. Two Cubs and two AEC vehicles made up the Buxton coach fleet (numbers 713, 766, 777 and 849). The first of these had the registration LDB 713, and was a 1957 AEC Burlingham Seagull capable of carrying 41 passengers.

Perhaps one of the best known routes to Buxton was number 27 which plied between the spa town and Manchester. The service began carrying passengers as far as Stockport in the early 1920s, being extended to Lower Mosley Street, Manchester in 1928. The 27 bus was popular with locals, hikers and visitors who wanted to explore the Buxton area. In spite of this, Long Hill journeys were withdrawn in 1971, the service no longer running to Manchester on weekdays, but turning round at Stockport.

The route went over to Trent control in 1972, re-numbered number 3, later becoming 199. With the popularity of the car and competition from the railway, Sunday services ceased running to Manchester in 1975, but today there is still a route between Stockport and Buxton.

Bus enthusiasts and local residents may remember that it was on March 4th, 1972 that North Western properties at Buxton, Castleton and Matlock passed over to the Trent Motor Traction Company Limited, together with the services and vehicles. The area is still well served by Trent who celebrated 75 years of public transport in 1988.

The National Tramway Museum. Any reference to transport in the Buxton district must include the working museum of trams at Crich, just six miles south-east of Matlock. Established in 1959 in what was a derelict limestone quarry the museum now contains a fine collection of some 40 tramcars from Britain and overseas built between 1873 and 1953. A third of these are in working order and a regular service operates over a one-mile electric tramway when the museum is open.

But do not imagine that Crich is just a few trams and a length of track. There is a wealth of street furniture and architecture to enjoy. On entering the museum, visitors walk under the pedestrian archway of a bridge spanning the tramway. Stephenson Place is a paved area around

Opposite: This early North Western bus is pictured outside the 'Cat and Fiddle' public house.

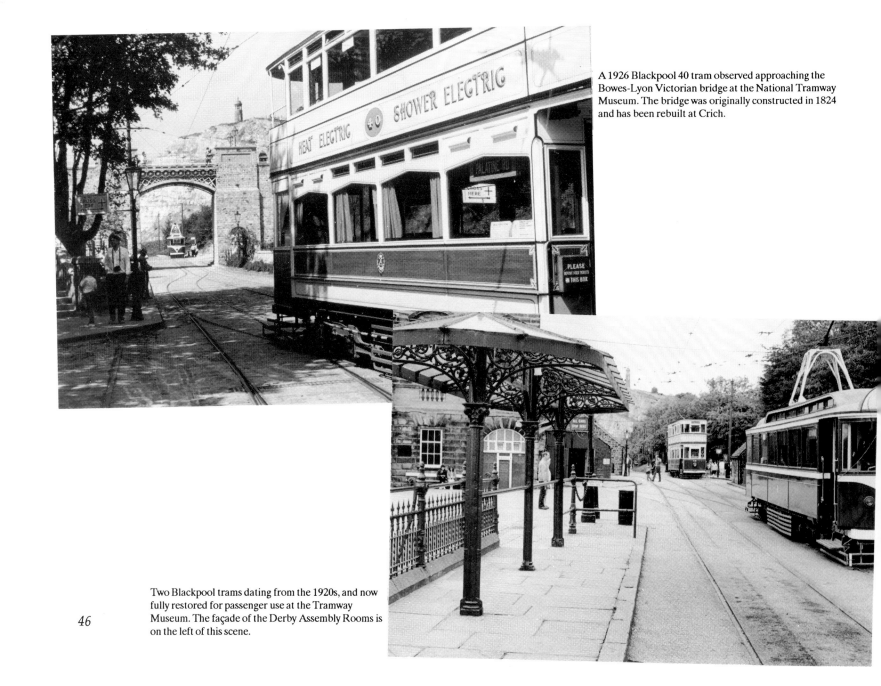

A 1926 Blackpool 40 tram observed approaching the Bowes-Lyon Victorian bridge at the National Tramway Museum. The bridge was originally constructed in 1824 and has been rebuilt at Crich.

Two Blackpool trams dating from the 1920s, and now fully restored for passenger use at the Tramway Museum. The façade of the Derby Assembly Rooms is on the left of this scene.

the bookshop with stone flags from Leeds and working gas lamps coming from Oldham. The tram stop sign and its pillar once graced the streets of Liverpool, while the 'Penfold' design pillar box is over a hundred years old. Visitors will then come across a small stone building, 'The Eagle Press' which served the original quarry railway as a weigh-bridge office.

A number of signs represent several areas of Britain, with 'Tramway Street' coming from Leeds and 'Chaceley Grove' once having been in Birmingham. An 'Electric Avenue' sign by the shelter also hails from this last city, and typifies the ornate design used by many municipalities in Victorian days.

Perhaps one of the most impressive static attractions at the museum is the façade of the Derby Assembly Rooms, which dates from 1784. Following a disastrous fire and redevelopment of the town's centre, the façade was taken down stone by stone, transported to Crich and rebuilt on its present site.

The ground floor of the Assembly Rooms contains a tramways exhibition, and just in front of the building you will notice two lamp standards. These came from Ashton-under-Lyne and were specially cast to commemorate the Diamond Jubilee of Queen Victoria. So, the National Tramway Museum has much to offer in terms of street architecture, buildings of yesteryear and historical photographs.

The depot complex is bounded by a stone wall surmounted by iron railings, which were originally erected around a Leeds school in 1883. One of the depot buildings contains a number of 19th century vehicles and equipment including a two horse-drawn tramcars which are over a hundred years old. The second hall, in addition to housing a display of tramcar models, depicts the development of the electric train from 1896 to the mid-1930s.

The focal point of the museum for many visitors is, of course, the collection of vintage trams, built between 1873 and 1953 for many towns and cities in the British Isles and abroad. There are usually two or three electric trams in operation on any one day, running every few minutes, with power supplied from a sub station.

Most of the tramway is built on the site of a section of a narrow gauge mineral line. This was originally developed by the great railway pioneer, George Stephenson, to link a limestone quarry to the main railway line at Ambergate.

This unique working museum is an essential place to visit for pupils studying humanities, transport enthusiasts, and older people who wish to recall those halcyon days when trams trundled along cobbled streets.

Railways

Cromford and High Peak Railway. Many people associated the 1860s as the time when

Sadly the east wall with its distinctive far window (1865) is the only reminder of the LNWR station at Buxton.

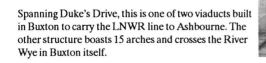

Spanning Duke's Drive, this is one of two viaducts built in Buxton to carry the LNWR line to Ashbourne. The other structure boasts 15 arches and crosses the River Wye in Buxton itself.

railways made their impact on the Buxton area. However, it should be noted that the Cromford and High Peak Railway (CHPR) was opened as early as 1830. Built to connect the Cromford Canal with the Peak Forest Canal, the first section from Cromford to Hurdlow began business in 1830 with the remaining $17^1/2$ miles commencing duties a year later. Stations or wharfs were built at Hurdlow, Parsley Hay and Friden, the railway serving quarries such as Grin and Harpur, near Buxton.

The first section from Cromford to the summit level of 1264 feet at Hurdlow used five inclined planes worked by stationary engines. The second part of this ingenious railway to the terminus at Whaley Bridge featured four inclined planes, three worked by stationary engines, with the final descent to 517 feet at Whaley Bridge employing a counterbalance system. On level sections, horses were used until superseded by locomotives in 1841.

Passengers were first carried in 1833, paying two shillings and sixpence ($12^1/2$ pence) for a single ticket from Cromford to Buxton, with a coach connection at Ladmanlow. A short extension from Cromford Wharf to High Peak Junction linked it to the Manchester, Buxton Matlock and Midlands Junction Railway in 1853, but this encouraged only a small increase in usage.

So it was not surprising that the CHPR was dissolved in 1887 when completely taken over by the LNWR, with the section northward from Parsley Hay absorbed into the LNWR Buxton-Ashbourne branch line five years later. The Whaley Bridge - Ladmanlow stretch was then closed, apart from a small length on the final section, including the Whaley Bridge inclined plane. This continued in use for a further 60 years.

The CHPR carried on transporting stones from quarries on the Parsley Hay - Cromford section until 1967, and today there are still some reminders of this unique railway. These would include the Middleton Top engine house, Hartington signal box and the various inclines used by this fascinating mode of transport.

Other Railways. We have already seen that the advance of railways was one major factor accounting for the growth of Buxton. Plans to construct a line from Stockport to Whaley Bridge had been authorised in 1854, and three years later trains on the LNWR Edgeley Junction - Whaley Bridge route began transporting people and goods.

Competition was strong between the LNWR and the Midland Railway, partly because of the latter's efforts to establish routes in the Peak District. However, it was decided that in 1863 celebrations would be held to welcome the arrival of two new railways. These were the Midland from the south east and the Stockport, Disley and Whaley Bridge Railway from the north-west. Buxton then had two new stations side by side ready by accommodate the two railways, with the Midland arriving triumphantly on June 1st, 1863. Unfortunately the SD and WBR contingent had to wait until June 15th. Sadly, the only reminder of the two fine station

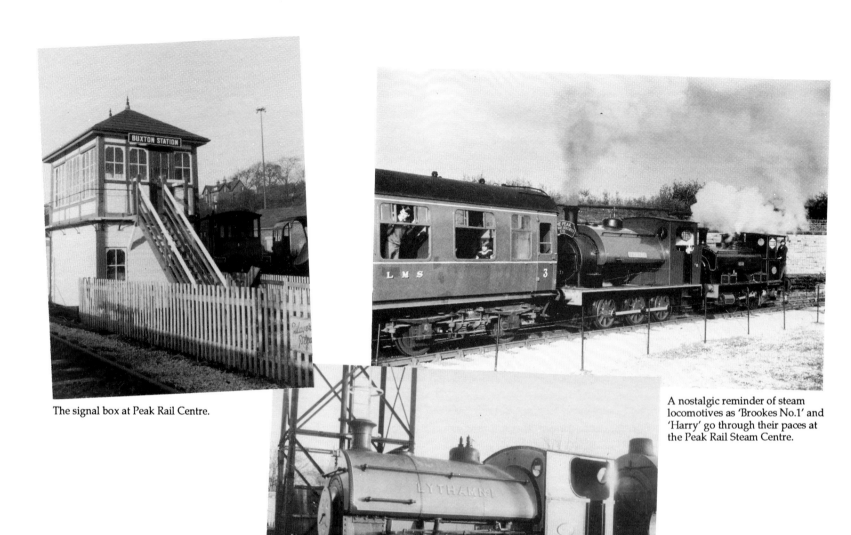

The signal box at Peak Rail Centre.

A nostalgic reminder of steam locomotives as 'Brookes No.1' and 'Harry' go through their paces at the Peak Rail Steam Centre.

'Lytham No.1' is a 1949 0-4-0 saddle tank engine based at the Steam Centre.

buildings, is the end wall of the LNWR terminal with its distinctive large fan window.

Railways opening up new routes to the spa town necessitated the construction of bigger and better hotels to accommodate visitors. One example was the Palace Hotel whose first guests arrived in 1868, just five years after the two Buxton stations went into service.

In 1899 the LNWR opened its branch from Ashbourne with a loop to the old SD & WBR at Whaley Bridge. This provided the LNWR with an alternative route to Buxton and Manchester via Nuneaton, and it also challenged the Midland route to London. Trains ran on the LNWR line from Euston to Buxton via Nuneaton and Ashbourne until 1917. To accommodate the new route a tunnel was constructed at Hindlow, while two viaducts were built in the town and across Duke's Drive.

In the mid-1950s the Ladmanlow goods yard was closed, and the year 1957 will be remembered by many local residents when a goods train ran out of control from Dove Holes, hitting another goods train at Chapel-en-le-Frith. The driver remained at his post until the end. This gave rise to *The Ballad of John Axon*.

1968 saw the last of the direct St. Pancras to Manchester express services transferred from the Peak line, gangs then removing track between Chee Dale and Matlock. However, organisations like the Peak Railway Society are determined to restore the Peak line for everyday and recreational use. In 1988, Peak Rail launched a major share issue designed to raise £250,000 in order to finance the construction of the first stage of a revenue-earning railway from Matlock to Darley Dale.

Buxton today is served by the British Rail route which runs via Stockport to Manchester, the 25 mile journey taking just under an hour. The railway is often the only way out of the spa town when heavy snow closes roads. In these conditions, it is not uncommon to see a snow plough at work clearing the tracks.

Buxton Steam Centre. Do you miss those nostalgic days of steam trains? Would you like to help in reopening the former Buxton-Matlock Railway? If the answer to these questions is in the affirmative, then visit Peak Rail Steam Centre's site adjacent to the main line BR station at Buxton.

Adults and children will enjoy looking at a number of engines, including 'Harry' - a dark blue 0-4-0 saddle tank built in Scotland back in 1924. This was the last conventional steam engine in regular use in Britain until it retired to Buxton in 1984. 'Arthur' is a green 0-6-0 saddle tank whose working life was in a Kent cement works.

'Brookes No.1', a dark red 0-6-0 saddle tank industrial shunting engine built in 1941, spent its days in a Yorkshire factory. Another shunting engine, 'Lytham No.1', is a 0-4-0 saddle tank from 1949. The blue and red locomotive came from Blackpool Gas Works via a museum at

The Peak Forest Canal at Buxworth used to be a hive of activity as gritstone and limestone was transferred from the Peak Forest Tramway to boats waiting in three basins.

Pictured cascading through Buxton's Pavilion Gardens, the River Wye rises 1,100 feet up on the eastern slopes of Axe Edge.

Lytham St. Anne's, and like the other engines, belongs to a Peak Rail member. A more local exhibit is 'DS 48', a small green diesel shunting engine from a Buxton quarry.

Of course, these fascinating engines do not lie dormant at Peak Rail Steam Centre. They are used for steam train rides which are normally available every Sunday and bank holiday until the end of September. The carriage hauled by the locomotives dated from 1950s for British Rail (a MK 1 BSK type no. 34558).

Other items of interest include the Engine Shed, a Mess Coach, signal box and a collection of rail vehicles in various station of repair. Examples of these are '92214' a '9F' 2-10-0 heavy freight engine built in 1959; '48624', a 1942 '8F' 2-8-0 locomotive; an 0-6-0 LMS tank engine; a Manchester Ship Canal Company diesel shunting engine, and even a self-propelled diesel 30 ton crane!

So what exactly is Peak Rail and what does it hope to achieve? It was formed in 1975 with the intention of reopening the whole of the 20 miles of railway from Buxton to Matlock, closed in 1968 to passenger traffic.

Even though much of the track was lifted, the actual trackbed is in good condition. Older travellers will recall that this was one of the most scenic railway routes in England, passing through beauty spots such as Ashwood Dale, Miller's Dale and Monsal Dale. Happily a group of rail enthusiasts and environmentalists made positive moves to rectify the situation, leading to the formation of the Peak Railway Society Limited. Together with Peak Rail Operations Limited, the Society aimed to restore the Peak Line for recreational and every day community use.

1987 was an important year in the progress of Peak Rail with work starting an replacement of the Buxton Bridge which will link the Buxton Steam Centre to the British Rail line at Ashwood Dale. In the following year considerable progress was made on the relaying of the railway track from Darley Dale southwards to Matlock.

If you wish to assist with this ambitious scheme of linking Buxton to Matlock, then why not become a member of Peak Rail or apply for shares in Peak Rail Plc?

Waterways

Peak Forest Canal. Rocky terrain and impossible gradients proved too much for Brindley and other canal builders and the only man-made waterway near Buxton is the Peak Forest Canal. It ran from Buxworth for 14 miles to join the Manchester, Ashton and Oldham Canal, thus allowing the transportation of goods direct to Manchester.

A short branch from Whaley Bridge met up with the main canal just north of Buxworth. Its main purpose was to carry products from the limestone quarries at Dove Holes. It was in the

Buxworth basin that gritstone and limestone was transferred from the Peak Forest tramway to waiting barges in the three basins.

The Peak Forest Canal opened in 1800 and could accommodate boats measuring 70 feet by 7 feet. On leaving Furness Vale and Bridgemont, there was a fork in the canal. The way to the right led to Whaley Bridge, while the one to the left went to Buxworth. But how was limestone and lime transported from kilns and quarries at Dove Holes down to Buxworth Canal basin, some six miles away? Well, the answer was provided by the Peak Forest Limestone Tramway which had commenced operations in 1796.

This intriguing idea covered the six miles by negotiating an 85 yard tunnel at Chapel Milton and a 209 foot inclined plane at Chapel-en-le-Frith. Its original track had a gauge of 4 feet 2 inches which carried waggons propelled by gravity, although teams of horses hauled the waggons to the highest point on the line, at 1,139 feet.

At this point the horses were unhitched and a string of waggons were given a push by a man to start them on the descent to marshalling yards close to Chapel-en-le-Frith. There then followed a trip downhill, the weight of the waggons used to haul up empty ones by means of a wire rope. On covering the two miles from there to Buxworth Basin the limestone or lime was transferred to barges.

Restoration of the basin area has been going on for some time. In mid-1989 High Peak Borough Council supplied money which was used to complete the rebuilding of two horse transfer bridges at the Buxworth basin on the Peak Forest Canal which closed in the 1920s. Canal enthusiasts will know that the 18th century basin is the last surviving tramway interchange in the North West, and when restoration work is completed in late 1989, the Peak Forest Canal will once more be linked with the rest of the country's inland waterway network.

It is likely that the early 1990s will see a museum housed in two stone warehouses at the basin where restoration has been going on for some 20 years.

The River Wye. For many people who came to Buxton, their only glimpse of the Wye is when it cascades through the Pavilion Gardens and Serpentine Walks. But how many visitors or even residents know where this river rises?

The Wye begins life on the gritstone 1,100 feet high on the eastern slopes of the Axe Edge, and runs as a clear mountain stream down to Buxton. Plainly visible in the Pavilion Gardens and Serpentine Walks, the Wye then goes underground beneath the Crescent, re-emerging in Ashwood Park at the far end of Spring Gardens. Having negotiated the area near the A6, the river passes through pleasant scenery, entering Chee Dale between the huge 300 feet cliffs of Chee Tor.

Following the waterway downstream, we see it proceed through Miller's Dale and from here you may wish top explore Litton Mill which dates from 1782. Meandering past Water-cum-

Opposite:
A steam train crosses the Monsal Dale Viaduct.

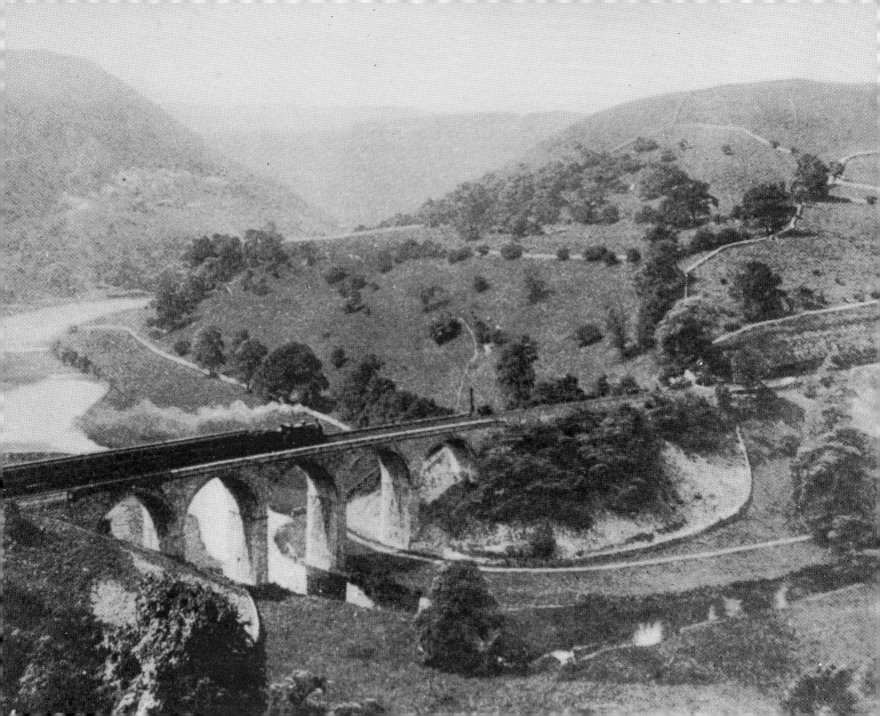

Jolley and huge limestone crags, the Wye flows past the famous cotton mill at Cressbrook. Then comes perhaps the most renowned stretch of the river as it makes its way through Monsal Dale with its famous viaduct. There are panoramic views to be enjoyed here and energetic people may wish to try the Monsal Trail. This follows the route of a former railway line down the Wye Valley.

Swinging west, the river is joined by Taddington Dale and below here the Wye slowly enters Ashford-in-the-Water where a 17th century sheepwash bridge is discovered. Flowing on to Bakewell, a mile or so away, the river makes its way under an impressive five arched 13th century bridge.

Nearby Haddon Hall occupies a bluff overlooking the Wye and an interesting packhorse bridge. Here there are large open meadows on the river's lower reaches where the Wye contribution much to the idyllic setting of the stately home.

The river's journey now takes it to Rowsley and the flour mill whose water turbines were first installed in 1885. This pretty village is the spot where one finds the confluence of the Derwent and Wye whose journey through breathtaking scenery is now at an end. For those who have followed part of the Wye's journey, the words of Wordsworth would perhaps summarise their feelings:

'Ne'er saw I, never felt a calm so deep!
The river glideth at his own sweet will.'
'Composed Upon Westminster Bridge'

The Town Hall is seen in the background of this view of Buxton's market place.

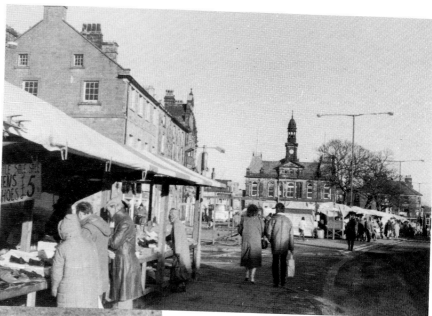

Lambing in the region usually lasts from March until May.

Chapter 5: Commerce and Industry

Buxton provides a fine selection of shops in two main areas of Spring Gardens and the Market Place. There are also undercover precincts such as the Cavendish Arcade and the Market Place Arcade. One of the town's attractions is the bustling market, and in spring 1989, High Peak Borough Council spent £45,000 to secure its future. Wooden stalls were replaced with metal ones, while new trailers were provided for use at the twice weekly market which is a vibrant tourist attraction.

The Peak District contains two principle geological formations - limestone and gritstone, with the variety in scenery adding to the appeal of this region. Of course, man has made his impression on the area from the earliest times when people from the Mesolithic, Neolithic and Bronze Ages producing pottery, stone hammers and bronze implements.

In addition to enjoying Buxton's waters, the Romans were attracted by the lead in the district. The Middle Ages brought considerable development of farming. The 18th century Enclosure Acts and the need to exercise stock control heralded the advent of dry-stone walling, a notable aspect of Peakland today. The farming industry is clearly an important form of employment, together with quarrying and tourism. These will now be considered in some detail.

Farming

The Peak District is an area of limestone topped with millstone grit or shales. The steep slopes, inclement weather and quality of the soil encourage pastoral rather than arable farming. The southern and central limestone is well drained, and with the assistance of lime, produces pasture ideal for livestock farming. Here one finds two or three dairy cattle to three or four acres. The clay soil on top of shale in the Wye and Derwent Valleys, coupled with shelter offered by the valleys also encourages dairy farming.

It was the coal mining and lead producing communities who provided a market for dairy products in the 19th century, and today about 90% of the region's daily output is consumed as milk in Manchester and Sheffield. The remaining 10% is employed for such dairy products as cheese, for example, at Hartington, famous for its Stilton cheese. Dairy farming predominates the White Peak which occupies most of the central and southern Peak District where black and white Friesian cattle are a common sight.

Most of the sheep in the Peak National Park are Scotch Blackface, Swaledale or Derbyshire Gritstone. This last breed is a hornless variety originating in the Goyt Valley, and may frequently be found near picnic sites on roads around Buxton. Lambing takes place between

Conveniently located just to the north-west of Buxton's railway station, the palace Hotel is over one hundred years old.

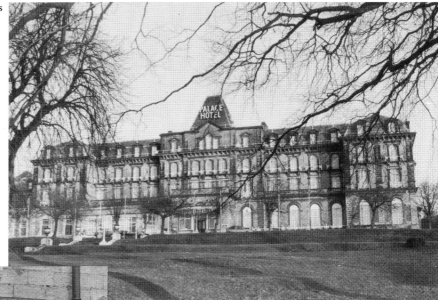

How many locals know that 'The King's Head' was originally the manse for the adjacent Presbyterian chapel? The hostelry was an important stop for horse-drawn coaches, and today its dispenses Marston's Ales.

March and May depending on the height of pastures, and it is not uncommon for sheep to be brought down to the 800 feet level in winter months.

Important farming markets are held every week at Bakewell and if you want to see shepherds put sheep dogs through their paces, then visit local trials in the summer months at such places as Hope or Longshaw.

Quarrying and Mining

Mining is not new in the region, and it is clear that the Romans were attracted not only by Buxton's spring waters but also by the presence of lead. The Odin Mine beneath Mam Tor is traditionally associated with the Saxons, though little evidence exists to support the theory. However, a visit to this oldest recorded lead mine in the Peak District will reveal a horse-drawn wheel which was used to crush lead ore.

Lead mining continued to flourish until the mid-19th century, Peakland people practising a dual economy of farming and mining. This second industry does not exist today but many locals find work in massive limestone quarries or in fluorspar extraction, often on the old lead rakes. Some people would argue that huge quarries and crushing plants detract from the Peak's natural beauty. But it must be remembered that quarrying is a way of life with local inhabitants, and for many years this industry has been the main employer in the Buxton area.

A detailed consideration of the historic Castleton caverns will be given in the next chapter, and in order to provide an insight into quarrying, the work of ICI in Buxton will now be examined.

The outcrop of carboniferous limestone in Derbyshire and Staffordshire covers an area approximately 27km from north to south and 13km from east to west. Limestone in the Buxton area is renowned for its high purity and its presence in massive deposits. This was known to the Romans who quarried it to make quicklime by subjecting it to high temperature in kilns fired by faggots of wood. The remains of old kilns in the Buxton district testify to lime burning taking place in the 16th, 17th and 18th centuries.

Many small works sprang up in the Buxton area to meet the increasing demand for quicklime in the 18th and 19th centuries. John Brunner and Ludwig Mond built their Alkali works at Winnington, Cheshire in 1873 to make soda ash by ammonia soda process. By 1898 the annual output was approaching 200,00 tonnes which required large quantities of quicklime and carbon dioxide. The competition amongst small lime works around Buxton was keen as companies tried to secure the Brunner Mond order. However, in 1891 quarry owners amalgamated to form the Buxton Lime Firms Company Limited, and in 1919 Brunner Mond acquired a controlling interest in the organisation.

The company became known as the Lime Group of ICI, and now Buxton is the headquarters of the Lime Products Section of Mond Division's Alkali Group. In addition to supplying large tonnage of material to many ICI works, it also sends growing quantities of its products to a host of other industries spread throughout the length and breadth of the UK. ICI production facilities at Buxton allow the company to produce a comprehensive range of products - quicklime, hydrated lime and ground quicklime which is located at Hindlow quarry.

Tourism

The Peak District has been a popular haunt for visitors for centuries, even although it was described by Daniel Defoe in 1725 as 'the most desolate, wild and abandoned country in all England'. Happily, the area is now more welcoming to the 18 million people who live within 40 minutes drive of the Peak National Park. An increasing number are spending time camping, caravaning and walking in the area, and farmers supplement their income by providing camp and caravan sites.

In Buxton itself there are many comfortable hotels, guest houses and pubs catering for all tastes. These provide employment for local folk, and the ones now described are just a selection of historic building visitors may wish to explore. The Old Hall Hotel is described in Chapter 2 and of course the town relied heavily on other places, including 'The White Hart' which dates from 1752, and 'The Grove', an historic 18th century hotel. In the early 1800s visitors could choose from 17 hostelries and hotels in Buxton, half of which were owned by the Duke of Devonshire.

Today's hotels include those housed in historic buildings such as Hawthorn farm Guest House which occupies a 400 year old listed building. Similarly, there is the Old Manse on Clifton Road and the Lee Wood Hotel, dating from 1839. It is in a convenient spot, close to town centre and provides 38 en suite bedrooms.

Biggin Hall is an historic house of 17th century origin, standing in its own spacious grounds of eight acres. Many of the stone-mullioned windows have only recently seen daylight after their obliteration during the window tax period of the 1790s. The large rooms of this Grade II listed building are individually furnished with antiques, and all bedrooms enjoy en suite facilities.

The Eagle Hotel is an old coaching inn, originally on the London-Glasgow route. In 1760 the Duke of Devonshire rebuilt 'The Eagle and Child' whose name was altered to 'The Eagle' in 1820. The place underwent another name change at the start of the 20th century in an attempt to attract a better type of clientèle. It was called 'The Devonshire Arms' but this hostelry in the market place has now reverted to 'The Eagle'.

The modern Ferodo factory at Chapel is an important local employer for Buxton and district. More than 20 million disc pads are produced here each year.

It was in 1903 that the old Sovereign Mill at Chapel-en-le-Frith was occupied by the Herbert Frood Company.

The King's Head Hotel. was built in 1750 as the manse for a Presbyterian chapel erected on the Market Place in 1725. In order to raise money, the manse was leased as an inn, serving as a coaching house. Today's 'King's Head' is a popular watering hole dispensing Marston's beers.

The Palace Hotel, built close to the railway station in 1868, was ideally positioned for passengers who alighted from trains in Buxton. Set high above the town, the Palace Hotel is convenient for all local facilities. The 122 bedrooms come with en suite facilities, and the hotel possesses 11 meeting rooms of varying sizes which can cope with any sort of conference or training course. In fact, an inclusive 24-hour conference package has proved most popular in recent years.

Attached to the hotel is an impressive leisure complex comprising a number of attractions, including sun beds, saunas, indoor swimming pool and hairdressing salons. Now in its second century, the Palace commands good views of the countryside around Buxton, and its existence certainly adds much to the town's appearance.

Examples of Local Industries

It is not possible to describe every industry in detail, so two well known organisations will be looked at. These are Ferodo and the Explosion and Flame Laboratory, Buxton.

Ferodo, the internationally famous company, has its headquarters at Chapel-en-le-Frith where it provides work for many people in Buxton and surrounding districts. In fact, of the 2,600 employed by Ferodo in the UK, some 1,600 are based at the Chapel factory.

The founder was Herbert Frood who realised the importance of brake shoes for horse-drawn vehicles, and so in 1897 he invented a brake lining material. Six years later he acquired the old Sovereign Mill at Chapel, with Ferodo becoming a public company in 1920.

Ferodo has grown to become one of the world's leading manufacturers of friction materials, whose industrial sites are found worldwide. Two Queen's Awards to Industry for technical innovation and an unsurpassed pedigree of motorsport success are indicative of the excellence of Ferodo products. In fact, 23 World Grand Prix Championships have been won using Ferodo disc pads and this success continues today.

Ferodo disc pads and brake linings are fitted as original equipment to such makes of cars as Ford, Rolls Royce and Mercedes Benz, while commercial vehicle disc pads and brake linings are found on numerous makes of lorries. But the company does not restrict itself to road vehicles, with Ferodo railway disc pads and brake blocks employed by British Rail and most trains on the London Underground. The Chapel-based firm's products are also found on tractors and motorcycles.

The future looks promising, since investment for success is the theme that is leading Ferodo

and its Chapel-en-le-Frith operations into the 1990s and beyond. Computer-controlled robotic technology has already revolutionised the production of disc pads, 1989 bringing a new automatic mixing and manufacturing plant.

The complex has come a long way since the days in the Sovereign Mill, and Chapel's site is the headquarters and main manufacturing plant for the many companies within the Ferodo organisation. It is also the home to the main research and testing facility - the largest of its type in the world. About 20 million disc pads, 14 million car lining and 2 million commercial vehicle linings are produced each year at Chapel's site which covers an overall area of 45 acres.

The central distribution fleet of rigid and articulated trucks travels a total of 400,000 miles per year, including a daily service to Ferodo's Caernarfon factory. Herbert Frood would have been proud of today's operation where product development and research guarantee that Ferodo maintains its position as a world leader in friction technology.

The Explosion and Flame Laboratory, Harpur Hill, Buxton became operational in 1926. How many locals or people passing this place know what actually takes place there? To answer this question we have to look at the history of mining.

Coal mining had long been affected by problems of roof collapse, shaft accidents and flooding, the first recorded accident caused by firedamp taking place in Gateshead in 1621. Various efforts were made to tackle underground problems, and this led to innovations such as the Davy lamp.

The Mines Inspectorate was formed in 1842 and two years later Michael Faraday drew attention once again to the affect of coal dust in extending the flame of an explosion. In 1891 a Royal Commission was appointed to enquire into the effect of coal dust in originating or extending explosions in mines, while a similar commission of 1906 looked at the health and safety of miners.

In 1920 the Mining Industry Act set up the Mines Department of the Board of Trade for the purpose of securing, 'the safety and welfare of those engaged in the mining industry'. A Mines Department Experimental Station was established at Eskmeals and it was then felt new premises should be found in a position central to the coal fields, near a university town, with living accommodation nearby. By the end of 1923 no suitable site had been discovered, although Castleton and Edale were considered. Early in 1924 a location was found at the Frith, Harpur Hill near Buxton. A small coal field close to the spa town had ceased production in 1921, the nearest coal mine entrance being about two miles from the chosen site.

So it was that 411 acres were leased in reasonable proximity to Manchester and Sheffield. By June 1926 experimental work was in progress, the official opening taking place in June 1927.

One advantage of the Buxton site was a 1,500 foot stretch of level ground on which explosion galleries could be installed immediately. Interestingly, this was a disused stretch of

Standing : Mrs. M. Wheeler C.B. Platt C.S.W. Grice J. Grundy F.V. Tideswell H.F. Coward R.V. Wheeler O.C. de C. Ellis
E. Fudge H. Hudspeth W. Payman E. Franz

Seated : Van Oudenhove (Belgium) L. Delmas (France) Ebbinghaus (Germany) A. Breyre (Belgium) E. Beyling (Germany)
E. Troup E. Audibert (France) G. Rice (U.S.A.) Rother (Germany) H. Schultze-Rhonhof (Germany) E. Fischer (Germany) J. Thorpe

The year is 1931 and representatives from mines research laboratories in various countries attend a meeting at Buxton. Not the detailing above the windows in a building designed by local architects Garlick and Son. They obviously had a penchant for Egyptian Styled flat roofs and articulated façades.

the Cromford and High Peak Railway (see Chapter 4: 'Transport and Waterways') which was diverted locally in 1875.

The main laboratories were housed in Sheffield University, and although research work on explosives was carried out at Eskmeals, Ardeer and Sheffield, more work was concentrated on the Buxton site from 1925 onwards.

A 'gob fire' chamber for the study of spontaneous combustion was among the original buildings at Buxton. This had a chequered history - damaged by an internal explosion in 1927, rebuilt the following year, damaged again in 1932 and reconstructed and extended in 1933!

1928 brought several developments at Buxton, including a building for testing coal cutters in gassy atmospheres, together with a new block which housed a dining hall catering for 180 visitors. The site received an Exhibition Hall and model mine face in 1932. Four years later a wing of the administration building was converted into a lecture hall.

By now, Harpur Hill was arousing considerable interest among locals and people further afield. This led to a scheme for showing visitors around the operations, and in 1937, 6,153 people were entertained at the site.

Following the Second World War, the work of the Safety in Mines Research Board was transferred to the Ministry of Fuel and Power. The activities at research stations at Buxton and Sheffield were brought together with those of other testing stations in the towns. This resulted in the formation of the Safety in Mines Research and Testing Branch in the Safety and Health division of the Ministry.

Developments carried on at Buxton where a surface explosion gallery 1200 feet long was constructed from reinforced concrete and an impact test track made its début in 1964. It comprised two rail tracks of differing gauges installed on opposite sides of a valley and overlapping in the valley bottom.

The Buxton site was extended in 1975 when two neighbouring farms were acquired, this increasing the land holding to 550 acres. The Section was rehoused in purpose-built accommodation, and in 1985 the Noise and Vibration Section was moved from Cricklewood to Buxton.

A disused section of the Cromford and High Peak Railway was used in the mid-1980s has an internal road joining the main site with the trials area. By now Buxton was at the forefront of testing LPG cylinders, the newest explosion facility at Harpur Hill being a $20m^3$ explosion vessel adjoining the coal dust explosion galleries.

In September 1986 special events took place at Buxton to mark 75 years of government research into mine safety. If you have the opportunity to visit the centre, then make full use of it, particularly if you can witness one of the most spectacular sights of a coal-dust explosion emerging from the 366 metre coal dust explosion gallery.

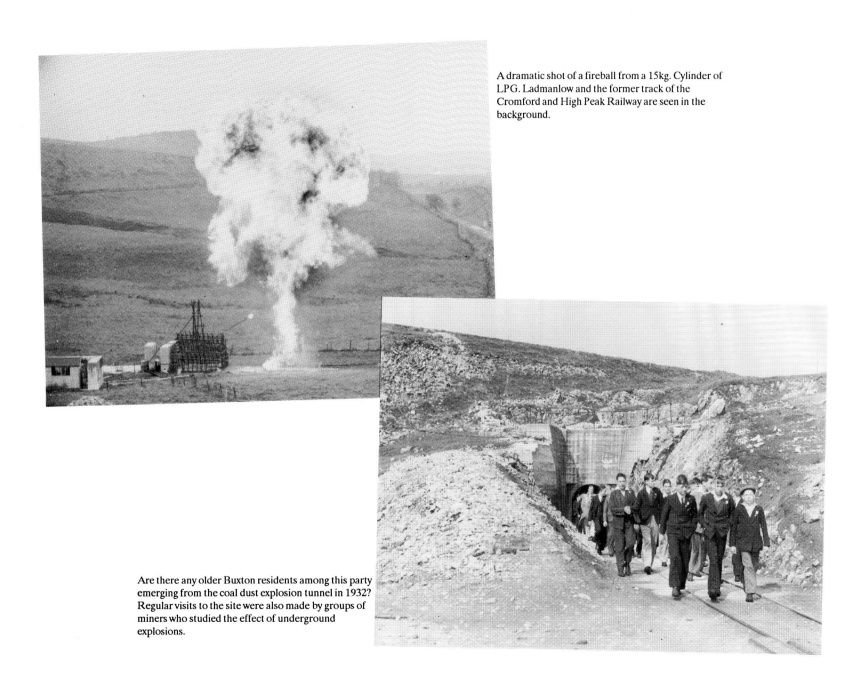

A dramatic shot of a fireball from a 15kg. Cylinder of LPG. Ladmanlow and the former track of the Cromford and High Peak Railway are seen in the background.

Are there any older Buxton residents among this party emerging from the coal dust explosion tunnel in 1932? Regular visits to the site were also made by groups of miners who studied the effect of underground explosions.

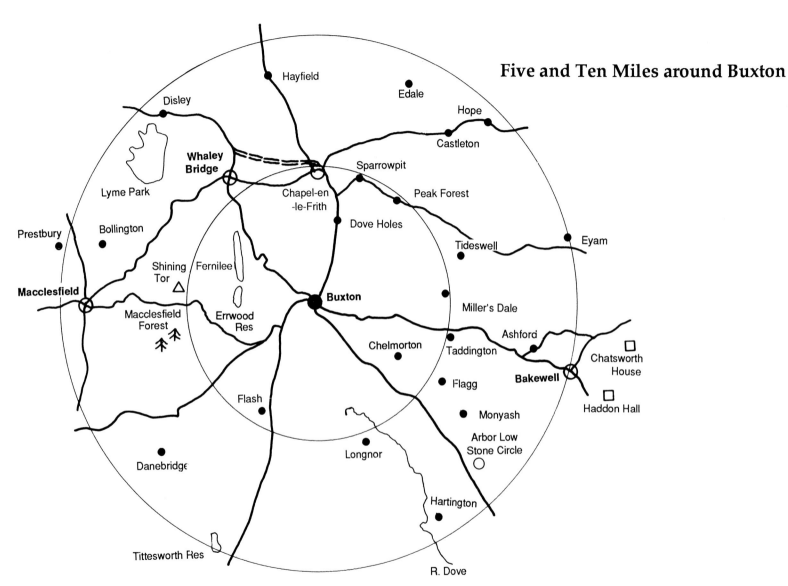

Five and Ten Miles around Buxton

Hayfield
Edale
Hope
Castleton
Disley
Sparrowpit
Whaley Bridge
Chapel-en-le-Frith
Peak Forest
Lyme Park
Dove Holes
Prestbury
Bollington
Tideswell
Eyam
Shining Tor
Fernilee
Buxton
Miller's Dale
Macclesfield
Ashford
Macclesfield Forest
Errwood Res
Chelmorton
Taddington
Chatsworth House
Flagg
Bakewell
Flash
Monyash
Haddon Hall
Danebridge
Longnor
Arbor Low Stone Circle
Hartington
Tittesworth Res
R. Dove

Surrounding Areas

For many visitors to Buxton their stay involves not just the spa town but also surrounding districts. The landscape within the Peak District can change dramatically in a matter of a few miles from thickly wooded dales to vast expanses of moorland. The Dark Peak is an area of untamed, rugged countryside featuring millstones, gritstone edges and the spectacular Kinder Scout. Much of the central and southern Peak District is known as the White Peak, where tourists can savour delightful dales, disappearing rivers, and examine the traces of lead mining. The dramatic appeal of the moorlands, numerous historic villages, and soft sylvan beauty of undulating countryside is within easy reach of Buxton. The variety is immense, ranging from Chatsworth House to the forbidding Mam Tor and Axe Edge.

The following are a selection of places you may wish to visit. These are grouped in two sections - Five Miles Around Buxton, and Ten Miles Around Buxton (in radius). All are easily reached within an hour's drive, with towns and villages listed in alphabetical order. Of course, these attractions should not be visited without first looking at a map. You may be able to combine several villages or places of interest in the one journey.

Five Miles Around Buxton

Chapel-en-le-Frith, situated within a stone's throw of Buxton, just off the by-pass, used to be known as 'the chapel of the forest [frith]'. Not surprising, considering the district was a royal forest, but what about the Chapel? The first place of worship was built by workers of the Peak Forest about 1225, although the present church is mainly of the early 14th century. It consists of a nave, octagonal piers and aisles of four bays. A new tower was added in 1773 and the church is dedicated to St. Thomas Becket. One interesting snippet regarding the church is that 1,500 Scottish prisoners of war were imprisoned there after the battle of Preston in 1648 for over a fortnight. Forty-four of them died in the overcrowded conditions.

A wander round the town will reveal stocks in the cobbled market place near the market cross, and, of course, Chapel is the headquarters of the famous Ferodo Company (see Chapter 5: 'Commerce and Industry'). Should you work up a thirst on your travels, then why not try a drink in one of the four pubs in the market place (where a market is held each Thursday).

Dole Holes, a sequestered clutch of houses on the Chapel to Buxton road, took its name from the expression, 'water swallow' or 'dwarf hole' as it is known locally. A water swallow is a hole into which a stream disappears, re-emerging at another place, possibly several miles away.

Close to Dove Holes is a stone circle called the Bull Ring, similar to the one at Arbor Low

(see below) and it is more than likely that Bronze Age man inhabited this desolate spot. The village played an important rôle in the Peak Forest Limestone Tramway (see Chapter 4, 'Transport and Waterways') with lime and limestone transported from quarries and kilns at Dove Holes down to the canal basin at Buxworth.

Flash is on the Leek road, about five or six miles out of Buxton. Akong the flank of Axe Edge keep your eye open for a right-hand turn to Flash. This is the highest village in England, more than 1,500 feet above sea level, and within its parish one can enjoy a drink in two of the highest pubs in the country.

The collection of cottages and their Parish church experience savage weather in winter months, and the isolated location encouraged such forbidden events as cock fighting and prize fighting. Of course, the name 'Flash' has nothing to do with grubby raincoats, but rather it stems from the illegal manufacture of counterfeit or flash coins. This was carried on at Pastures Farm on a button press. Since Flash is just inside the Staffordshire boundary but also close to Cheshire's border, the counterfeiters could quickly escape to a neighbouring county when the law appeared on the scene.

Miller's Dale is a pleasant half day run out from Buxton. Take the A6 in the direction of Taddington and Bakewell. Look out for the left-hand turning near Blackwell and proceed along the B6049 until Miller's Dale is reached. The actual dale runs eastwards from the small village of Miller's Dale which stands on the River Wye.

The village has declined in importance since the closure of the railway station which served surrounding villages. Derby to Manchester trains stopped here to pick up passengers for Buxton, and the line was also used for carrying limestone. Visitors cannot fail to notice two viaducts crossing the vale, the southern one built in 1862-63 for Midland Railway's main Manchester to London line. The northern one was added in 1905 to carry an increasing volume of rail traffic, and both feature rockface piers with metal superstructures.

When in Miller's Dale, follow the signposts to Litton Mill, a place infamous for its exploitation of child labour in the early 19th century.

Peak Forest and Sparrowpit have signs on the A6 Chapel to Buxton road indicating their location.

Peak Forest is associated with the railway and canal of the same name, but the village is also famous for its church. This was in fact a private chapel inside the Royal Forest and therefore beyond normal ecclesiastical control, which encouraged Gretna Green style marriages until 1804. At one stage 80 ceremonies a year were carried out in Peak Forest and in 1745 the number was 105. Unusually, the present church, dating from 1876-77, is, like its predecessor, dedicated to King Charles the Martyr (the executed Charles I). It was founded originally in 1657 by Christina, the Royalist Countess of Devonshire.

Chapel-en-le-Frith is a quintessential Derbyshire town, gathered round a fine old church built by Peak Forest workers in the early 13th century. Today's place of worship dates mainly from the 14th century, with a new tower constructed in 1713. An interesting sundial can be found above the entrance to the church.

Taddington is given much of its character by the
restored 14th century church dedicated to St. Michael.
The church has a west tower and a cross shaft in its
grounds, possibly dating from Norman times.

An axiomatic sign outside the village pub in Flash. In
addition to this hostelry's claim to fame, Flash also
possesses a church which occupied one of the highest
sites of any English place of worship.

Sparrowpit's frequent covering in white dust indicates the proximity of limestone quarries. The tiny place was once on the Manchester - Sheffield route before the construction of the turnpike which replaced the longer road via Whaley, Chapel, Sparrowpit and the nearby 'Wanted Inn' is one of the highest public houses in the Peak District.

Taddington, typical of many settlements in the area, avoids the deep valley floor, preferring a dry upland site. Located just off the A6 half way between Buxton and Bakewell, this village contains the Church of St. Michael whose north side surveys surrounding countryside. The west tower of dates from the 14th century with much of the structure restored in 1891 by Naylor and Sale. An ancient cross shaft in the churchyard probably dates from Norman times.

Taddington was a prosperous village of fatstock farmers in the 18th century, fattening cattle for the markets of Manchester and Stockport. Many of the houses date from this period. A half a mile or so from the village on Taddington Moor are the Five Wells Tumulus, some 70 feet in diameter.

Rugged Beauty

Axe Edge frowns down on Buxton just next to the A53 road to Leek. The summit of the Edge is more than 1,800 feet above sea level and it is here that the Rivers Manifold and Dove rise on the shales and grit. This watershed is also the place from which the Wye, Dane and Goyt begin their long journeys.

Nearby Panniers Pool Bridge spans the River Dane at a place called Three Shires Head. Some two miles from 'The Traveller's Rest' pub on the Buxton-Leek Road, this is the place where the three counties of Cheshire, Derbyshire and Staffordshire meet. Several pack horse routes once converged on the bridge and students of industrial archaeology may wish to visit Gradbach Mill. Now owned by the Youth Hostel Association it was once a silkmill powered by the surging waters of the River Dane.

The 'Cat and Fiddle' pub, a friendly building on the windswept A537 Macclesfield-Buxton road, is the second highest in England, occupying an elevated position of 1,690 feet above sea level. 'Tan Hill' in Yorkshire stands at 1,727 feet. It is worth making the relatively short drive from Buxton of only to enjoy the magnificent views of the Cheshire Plain, Jodrell Bank Radio Telescope and even the River Mersey.

When weather forecasts warn of heavy snow over the Pennines it is more than likely that the A537 is blocked, leaving the 'Cat and Fiddle' stranded. So what about the pub's background? Well, possibly built by 1831, it is said that one of the Dukes of Devonshire would journey to the inn where he practised his violin on the moors. This caused little annoyance to anyone except his accompanying cat. Another suggestion is that a game of 'cat' (trap ball) was enjoyed

by guests who played to fiddle accompaniment. Alternatively, how about the school of thought which argues that the hostelry was named in honour of the wife of Czar Peter the Great - Catherine la Fidèle?

Shining Tor. Having tested the beer at this lonely outpost, leave your car at the pub and take the track northwards to Shining Tor. The 'trig' point indicates that this is the highest point in Cheshire at 1,834 feet (559 metres).

Reservoirs and Rivers. Within five or six miles of Buxton there are three interesting reservoirs at Combs, Fernilee and Errwood. The first takes its name from a neighbouring village not too far from Whaley Bridge, with Fernilee and Errwood reservoirs seeking the seclusion of the Goyt Valley. If you go here by car, then check on the local traffic management scheme requiring vehicles to be left at Derbyshire Bridge. Errwood reservoir enjoys yachting facilities and there are lovely picnic sites overlooking the water.

Having savoured this sylvan splendour, why not have a look at the remains of Errwood Hall? This was the home of the Grimshawe family who planted the acres of rhododendron bushes which grow in profusion around the residence. Errwood reservoir dates from 1967 and adjoining Fernilee was built in 1938. If you wish to visit something a bit older, then make your way to Jenkin Chapel. Lying some $2^1/_2$ miles west of the Goyt Valley, this isolated place of worship was built in 1733.

Proposals in mid-1989 encouraged further development of the Goyt Valley when Derbyshire County Council allocated funding to create the six-mile Goyt Way from Whaley Bridge to the Greater Manchester boundary at Strines. Part of the Goyt Way will follow the towpath of the Peak Forest Canal, passing the impressive scenery of the Torrs at New Mills. The ambitious Goyt Way starts at the Whaley Bridge, linking up the Sett Valley Trail in the centre of New Mills and Stockport's Etherow-Goyt Valley Way.

Ten Miles Around Buxton

Within a radius of ten miles from Buxton there are many places of compelling beauty including tranquil villages, country homes and picture postcard scenery. In this section you are offered a wide range of places such as the Macclesfield Forest, the Hope Valley and even parts of Staffordshire.

Initially we consider a number of towns and villages in alphabetical order.

Ashford-in-the-Water, an entrancing village, lies ten miles from Buxton on the A6, heading towards Bakewell. There are three bridges spanning the Wye at this idyllic spot, with Sheep-wash Bridge acting as the venue for Ashford's well dressing ceremony. This usually takes place on the Saturday before Trinity Sunday and is well worth attending.

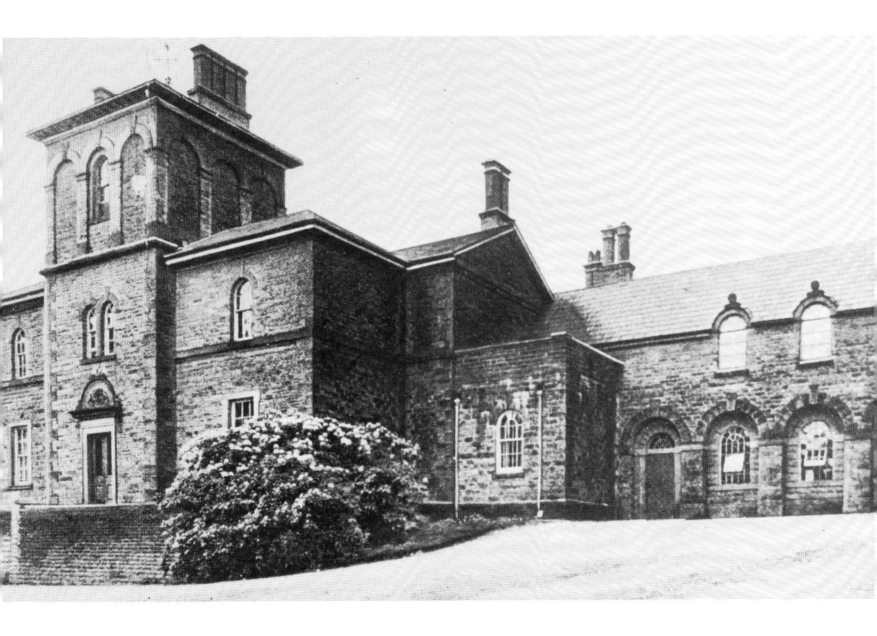

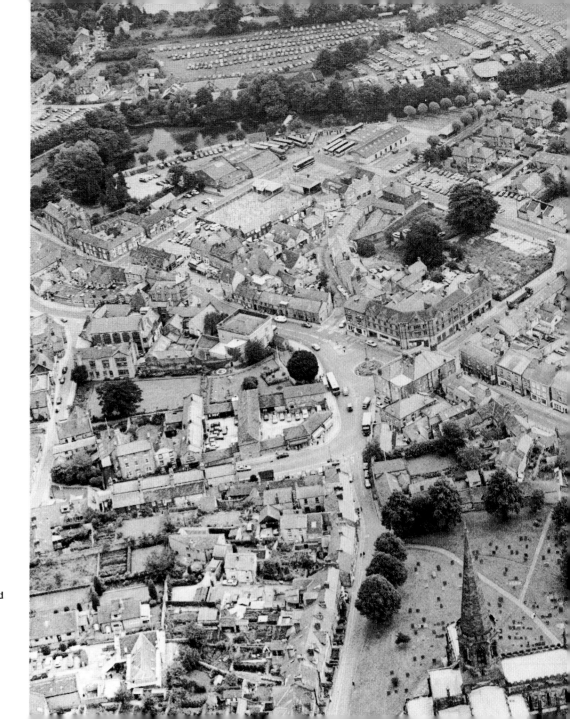

Straddling the River Wye, Bakewell has been an
important place at least since Saxon times. The
singular octagonal tower of the church may be observed
on the bottom right of this aerial view.

76

Holy Trinity church features a 14th century tower with much of the structure dating to the period between 1868 and 1870. The predominantly 19th century building retains a Norman tympanum over the south door, where the carving depicts a tree with a wild boar and a wolf.

Should time permit, take a walk round the village where there are good examples of 18th and 19th century stone houses. Keep a look out for the 17th century tithe barn and a water mill dating from the 1700s. Local mansions include 18th century Ashford Hall and Churchdale Hall. One mile away there is Fin Cop, an Iron Age promontory fort.

Bakewell is only a short drive along the A6 from Ashford. For many people, this town's claim to fame is its puddings, wrongly referred to as tarts. In Rutland Terrace on the Buxton Road there is situated the 'Rutland Hotel', dating from 1804 and it was here that the Bakewell Pudding made its début just over a century ago. A cook, told to make a strawberry tart, put the jam at the bottom of the dish instead of on top of the pastry, which resulted in a pudding rather than a tart. Not surprisingly, visitors are lured to the Old Bakewell Pudding Shop, not far from the old Market Hall. This dates from the 17th century and now functions as a National Park Tourist Information Centre.

With a population of some 4,000 inhabitants, Bakewell is the largest town and the administrative and commercial 'capital' of the National Park. Built around an important crossing of the River Wye, this picturesque settlement has been a place of importance since at least Saxon times. Interestingly, several stones and a cross from this period are preserved at the parish church.

All Saints, adting from the start of the 12th century, with its octagonal tower, is located above the town, dating from the start of the 12th century. It presents an interesting blend of several architectural styles with 19th century restorations. Often used by the Manners and Vernons of Haddon Hall, the church contains their monuments. The preserved stump of the Saxon cross in the churchyard and the discovery of pre-Conquest stones during restoration underline the age of All Saints.

Still looking back in time, the Domesday Book referred to the place as *'Badequella'*, meaning 'Bath-well' but, unlike Buxton, the town never became a spa. This does not mean there is not much to see and enjoy in Bakewell. For instance, the Monday market provides a variety of activities, including a cattle market, and the famous Bakewell Show takes place during the first week of August. Again, well dressing occurs on the last Saturday in June and a town carnival is enjoyed by locals and visitors alike in early July.

Architecturally, Bakewell provides a host of attractions ranging from the church and Market Hall to the Old House Museum, which dates from 1543. The old Town Hall is worthy of consideration along with Bagshaw Hall, dating from 1684.

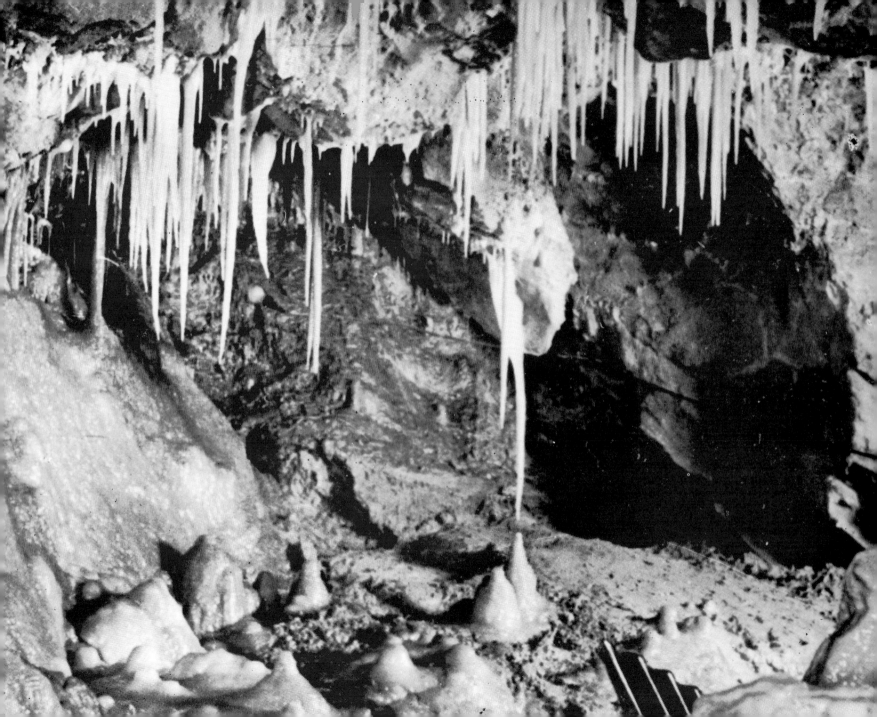

Be sure to examine Bakewell Bridge with its five Gothic arches, one of the oldest bridges in the country.

Bollington, nestling in the Pennine foothills, occupies a lowland site at the confluence of Harrop Brook and the River Dean, with surrounding hills rising to a height of more than 900 feet above sea level.

The Cheshire town, which can be included on your Macclesfield itinerary, is a place of contrasts with its stone cottages, comfy pubs and mill chimneys. The township derives its name from the Saxon words *'bollo'* and *'ton'* - the settlement of Bollo. Incidentally, should you wonder about the monument on Kerridge Hill, it is known as White Nancy, and was probably built to commemorate the victory at Waterloo.

Castleton, lying at the head of the Hope Valley just ten miles from Buxton, has strong ties with nearby Peveril Castle. This typical Norman stronghold had one William Peveril as its first occupant. Another William Peveril forfeited his castle to the crown in 1155 for the murder of Ranulf, Earl of Chester, to whom his lands had been granted by Henry II. The great tower was added in 1173 during the revolt of the king's sons against Henry II. The castle had its heyday in the reign of Edward I. Falling into disrepair after 1400, the castle was in ruins by the end of the 1600s.

Castleton is a pleasant place to explore as visitors are drawn to half a dozen pubs and the church, dating from Norman times. The local Youth Hostel, Castleton Hall, is a 17th century structure, and if you look carefully along the east and south sides of the village, traces of a mediaeval ditch may still be observed.

Village folk are keen to observe local traditions, exemplified by events on Oak Apple Day (May 29th), when the famous Castleton Garland Ceremony takes place. The main figure of the King rides a horse and is covered by a huge conical garland of flowers. Accompanied by his queen, the monarch leads a colourful procession through Castleton, stopping at the six public houses where beer is quaffed to the accompaniment of village girls performing a traditional dance. On reaching the churchyard the garland is hoisted to the top of the church tower. How did this unique ceremony originate? Well, some historians associate it with a festival to celebrate the restoration of Charles II, while others link it to the Green Man tradition, allied to the growth of crops in the new season.

Visitors from Sheffield and surrounding areas throng the streets of Castleton over the Christmas period. If you are in the vicinity why not enjoy the village's decorations and enjoy late night shopping in quaint gift shops.

Apart from sheep farming the main industry in the area was lead mining with this commodity probably mined before the Roman occupation. The theory is supported by ingots (or pigs) of lead, bearing the seals of various Roman emperors, discovered at local sites such as

Opposite:
Dream Cave in Treak Cliff Cavern where stalactites of all shapes and sizes hang in hundreds. When examining the varied forms in this cave, it is possible to pick out a number of natural imitations of well-known objects such as a stork on one leg, an elephant, and a crucifix.

The stocks on Eyam's village green.

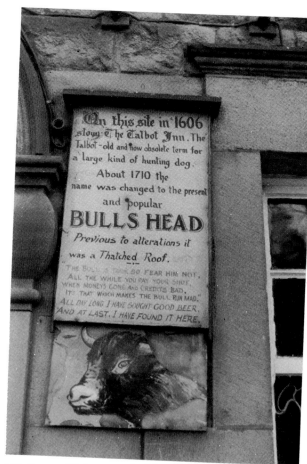

This Eyam public house received its present name about 1710, although a hostelry stood on the spot from 1606. An interesting couplet may be read in a sign outside the inn:
'All day long I have sought good beer,
And at last I have found it here.'

Navio (Brough). The 17th and 18th centuries were the busy periods for Derbyshire lead mines when workers discarded their waste minerals which are now being reworked for fluorspar (calcium fluoride).

Castleton is renowned for its remarkable caverns, and Mam Tor and Winnats Pass are further example of local sights. Numerous caves exist in the district. The famous ones being Blue John Cavern, Speedwell Cavern, Peak Cavern and Treak Cliff Cavern. The limestone in which these caves were formed is sedimentary rock laid down on the floor of a sea some 280 million years ago. The limestone became thousands of feet thick over a period of several million years and during the Carboniferous Period the land rose and fell, with limestone eventually buried under 4,000 feet of coal measures when the land rose for the last time. Following this, the weather has worn away the coal measures from the top of the limestone, and vertical cracks in the limestone filled with numeral fluids from within the earth. Over a period of time minerals were deposited in these veins or cracks. Examples of these included lead and fluorspar which encouraged mining in the area.

Blue John Cavern, found on the A625 just to the west of Castleton, is of tremendous geological and educational interest. Eight of the 14 veins of Blue John stone have been mined here for hundreds of years. Visitors are led along footpaths and steps to entrance of the first known 'working' of Blue John. This was discovered by the Romans 2,000 years ago and worked by them into vases.

Another working is known as 'Bull Beef' because of red tints in the mineral. This vein was used to produce the renowned circular table top which is on show at the Cavendish House Museum, Castleton. Moving on down the 'pothole' by means of a clean and safe staircase, visitors can marvel at the Grand Crystalised Cavern, while the Waterfall Cavern offers a fascinating stalagmitic formation from floor to roof.

Passing the 20 ton Balancing Rock, one arrives in a big circular chamber - Lord Mulgrave's Dining Room - measuring 150 feet high and 30 feet wide. It was here that his Lordship entertained miners. The Variegated Cavern measures 200 feet in height, containing many colours and a 'natural' Gothic arch.

Treak Cliff Cavern, just under a mile west of Castleton, had its caves carved out by underground rivers thousands of years ago. The first part of the cave was discovered by lead miners in 1750. The second range of caverns were found by Blue John miners in 1926 and all the caves were opened to visitors in 1935.

The spectacular Fossil Cave contains fossilised shells from the carboniferous seas, while the Witches' Cave features many veins of Blue John in their natural surroundings. Aladdin's Cave contains flowstone, with Fairyland coming next - a grotto of delicate stalactites highlighted by back lighting.

Perhaps the most memorable spot of the tour is the Dream Cave with its hundreds of glistening stalactites. The last chamber takes its name, the Dome of St. Paul's, from a lofty dome-like roof and multicoloured flowstone-covered walls.

Speedwell Cavern is a disused lead mine a quarter of a mile from Castleton which first mined in 1771, but was discontinued about 1790 after little had been found. The Speedwell Cavern entrance is at the foot of Winnats Pass, half a mile west of Castleton, and is unique in Britain since visitors are taken through the cavern by boat.

People are ferried 750 yards along a straight illuminated canal to the Bottomless Pit, guarded by stout iron railings. Water pours down the pit, disappearing for a 22 hour period before re-emerging just half a mile away at Russet Well - a natural spring in Castleton. Why is it called the Bottomless Pit? Well, miners tipped 40,000 tons of waste rock into the hole without it appreciably affecting the water level of the lake which is 70 feet below the railings. In addition to this phenomenon the guide will point out workings in the Speedwell Cavern, explaining various aspects of mining technique.

The caves above are quite different but all are spectacular. For more daring people how about trying a special adventure caving section at Bagshawe Cavern, Bradwell. Alternatively, experienced potholers and cavers may visit to explore the opportunities at Eyam, Bradwell and Stoney Middleton. Peak Cavern, in Castleton village, was used for ropemaking, and ropema-kers' cottages once stood in the entrance to the cave.

Castleton's charm, the deep caves and steep hills should feature on your itinerary when exploring the region around Buxton.

Chelmorton is an isolated community clustered round a main street. To reach it from Buxton, turn left off the A515, proceed for a mile or so and the characteristic limestone village is soon discovered close to the A5270.

Standing some 1,200 feet above sea level, St. John the Baptist church sports a low broad tower, recessed spire and battlements. Places to see in Chelmorton include Townend Farmhouse, a fine example of 18th century architecture displaying four Venetian windows. The country's only stone telephone kiosk, complete with slate roof is also worth viewing in the village. Visitors can hardly fail to notice the numerous narrow fields stretching away from Chelmorton, a legacy of the way in which medieval farming was carried out.

Danebridge, hiding in quiet lanes between the A54 and A523, south of Buxton, is a handy place from which to explore the Dane Valley, either in the Gig Hall Bridge direction or towards Back Forest.

Disley is a pretty Cheshire township, so if your travels take you along the A6 from Buxton to Manchester, then keep your eyes open for it, close to Lyme Park. Although the Domesday records carry no reference to Disley, its origins can be traced to the time when it was a clearing

Longnor is a pleasing mixture of quaint cottages and narrow streets.

in the Macclesfield Forest. The centre is Fountain Square and the village owes much of its development to the Legh family of nearby Lyme. Disley was the last village on the Buxton road in the days of horse-drawn coaches, and today you can enjoy a meal or drink in a host of inns and restaurants.

Edale, the focal point for much of the climbing and walking in the north of the Peak National Park, comprises five hamlets. The origins of the settlement probably lie with 'an island village' where a piece of land is bordered by rivers and their tributaries. Edale straddled one of the Yorkshire-Cheshire pack-horse routes where 'jaggers' or mule owners would transport salt and wool.

Built in 1885, the Parish church is the third one of its type in Edale, the first dating from 1633. Examples of other old structures in the area include Edale Mill, an early 19th century building originally designed as a flour mill. It was later converted to a cotton mill, ceasing production in 1934.

The remote village was considerably influenced both by the mill and the dawn of the railway era. The station opened in 1894, encouraging walkers to travel to the area where attractions include the Kinder plateau and the Pennine Way, which begins at Edale.

Eyam is synonymous with the plague of 1665. In this year a box of clothes was sent to the village tailor from London. But whilst drying the damp goods in front of his fire, George Vicars unwittingly activated a multitude of bubonic plague germs, carried by fleas hidden in the parcel.

The local vicar, William Mompesson, realised that his flock had caught the plague, and acting on his advice, the villagers decided to isolate themselves from the outside world. In fact, Mompesson's Well, situated high above the village, marks the spot where supplies were left for Eyam folk during their isolation period.

During the ensuing 15 months, 257 inhabitants perished, including Mompesson's wife Catherine, but thanks to the efforts of Eyam residents, it did not spread to surrounding areas.

If you pay a call to this notable village, visit Plague Cottage, where it all started, and have a look at Eyam Hall, the Delf, Cucklet Church and Bradshaw Hall. You may also wish to inspect the Poor House and the village stocks.

The Parish church probably dates from Norman times with restorations by G.S. Street. Renowned for the size of its chancel, St. Lawrence's possesses some fine wall paintings and early incised slabs. Other items of note include a Saxon font and an example of one of the best preserved Saxon crosses in England. Have a glance at the outside wall of the chancel where an unusual sundial shows the time in various parts of the world, in addition to giving astronomical data.

Of course, well-dressing has particular significance in Eyam since it commemorates the

heroism in the 1665/66 plague. Three wells are dressed on the last Saturday in August and an open air service takes place on Plague Sunday - the last Sunday of the same month.

Flagg comprises a clutch of dwellings high on a limestone plateau, and is perhaps best known for its point-to-point race meetings. Held each year on Easter Tuesday on Flagg Moor, the event is organised by the High Peak Hunt.

Hartington, lying half-way between Ashbourne and Buxton, with its population of 500, is two miles west of the A515 road. Hartington grew up around a central pond for watering cattle and is found in enchanting surroundings half a mile from the River Dove.

The 13th century church of St. Giles will arouse a certain amount of curiosity, since it features a red sandstone tower. The remainder is of limestone with gritstone detailing. Hartington Hall is a good example of a yeoman farmer's abode in the Elizabethan style, and since 1934 it has served as a Youth Hostel.

Of course, the village is famous for its cheese factory from where Stilton is exported to many countries. Historians will know that the Battle of Hartington Moor took place during the Civil Wars. There is something for everyone here, including fishermen! Charles Cotton, the 17th century poet and fisherman was born at nearby Beresford Hall. His book *'Wonders of the Peake'* received literary acclaim. Should you decide to explore the famous Hartington to Ilam footpath, call in at Rooke's Pottery where the workshop manufactures both terracotta garden ware and glazed pottery for the home.

Hayfield is a small town on the A624. Drive along the A6 from Buxton to Chapel, keeping an eye open for the A624 on the right. The town, once the home of many handloom wool and cotton weavers, is a pleasant place. How many houses with long 'weavers' lights' windows can you spot as you walk around the town?

Hayfield is a good starting point for walks to Kinder Downfall, Edale Cross and Kinder Scout. The rugged moorland rises to a height of 2,088 feet and since the weather can be unpredictable, even in summer, the terrain is suitable only for experienced walkers with full equipment and rations.

Hope, easily reached from Castleton or Winnats Pass, is dominated by the church dedicated to St. Peter. Built on the site of a Norman place of worship, the present structure was completed by the start of the 15th century. Have a look at the gargoyles on the south side of the church and also the Saxon cross shaft with its interlocking knotwork.

Local shops and pubs have a charm of their own, and three wells are dressed on the last Saturday in June.

Longnor, positioned just inside Staffordshire at the head of the Manifold Valley, only six-and-a-half miles away from Buxton, is an ideal centre of touring or walking. Those prefer-ring a little exercise could try the upper Dovedale Valley or local moorlands - but ensure you

take the correct gear for what is often wild terrain. For less energetic folk, leave your car and wander down the narrow alleys and lanes in Longnor. Reminders of market day tolls dating to 1903 are displayed above the cobbled Market Place.

Following your exploration of the area, choose one of the four, cosy hostelries where a well-earned pint can be enjoyed in convivial surroundings.

Macclesfield is a Cheshire town is within a ten mile radius of Buxton as the crow flies, and can be visited in conjunction with neighbouring Prestbury and Bollington. Take the A537 from Buxton, pass the 'Cat and Fiddle' inn, and enjoy an exhilarating drive to the silk town. For further details of Macclesfield and other areas of Cheshire you may wish to consult the Author's book, *'Cheshire - A Portrait in Words and Pictures'*. Macclesfield is referred to in the Domesday Book, and obtained its charter from Prince Edward in 1261.

The town contains fine examples of 18th century domestic architecture, together with a Town Hall dating from 1832-34. The silk town's impressive Parish church was founded by Queen Eleanor and King Edward I in 1278, containing a chapel built by Thomas Savage, Archbishop of York between 1501 and 1507.

During your sojourn in this Cheshire market town treat yourself to a trip to the Heritage Centre and Paradise Mill in order to gain an insight into the Macclesfield of yester-year.

Monyash, once the centre of lead mining in the High Peak, is a compact agricultural community, some eight miles from Buxton.

A church dedicated to St. Leonard can trace its roots to the 12th century, and local sights also include good examples of limestone domestic architecture and many mullioned windows.

Arbor Low, the prehistoric stone circle some two miles south of Monyash, is arguably the most well known of the Peak's prehistoric monuments. Here, weathered limestone slabs form a ring surrounded by a bank and ditch. Some pundits would argue that the stones once stood upright and their purpose is somewhat obscure. Could this have been the scene of some kind of ritual watched by people from the surrounding mound? Was there any correlation between activities at Arbor Low and those at Stonehenge or Avebury?

Whatever the answers to these questions may be, modern visitors will surely admire the fortitude of the early builders, toiling relentlessly in the Late Neolithic period, dragging lumps of limestone behind them.

Prestbury, lying close to Macclesfield, an up-market Cheshire village, is the recipient of several 'Best Kept Village' awards. Well worth a visit, Prestbury contains a host of architectural gems, including the National Westminster Bank housed in a 15th century black and white timber frame building. Opposite this is the Parish church of St. Peter and a Norman chapel. Remote from the bustle of city life, Prestbury is an unruffled village epitomising the serene English village.

The **Market Hall at Longnor** displays a Table of Tolls payable by sellers and buyers. Dated 1903, this notice contains a number of tariffs - four pennies had to be paid for stalls exceeding six feet in length, while one penny was charged for every pig.

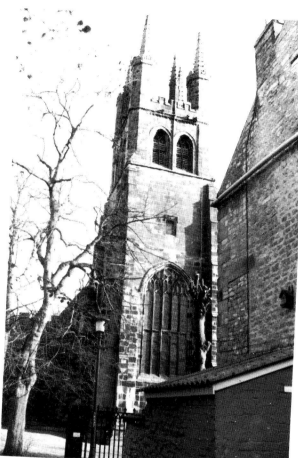

Above Tideswell's houses rises the noble church of St. John the Baptist. It is a fine example of Decorated architecture, having also some Perpendicular features. The imposing character of this church has earned it the title 'Cathedral of the Peak'.

Tideswell, if you are considering exploring the dales of the River Wye or walking 'The White Peak Way', is the perfect base, situated midway between Buxton and Bakewell, on the B6049. The spectacular Parish church fully justifies its title 'Cathedral of the Peak', built entirely in the 14th century and featuring examples of Decorated architecture with some Perpendicular characteristics. St. John the Baptist is the focal point of Tideswell, its tall, eight-pinnacled tower serving as an example of one of the country's earliest Perpendicular towers.

Step inside the church and enjoy a cathedral-like interior, containing huge arches, finely carved choir stall and an exquisite chancel screen. There are two chantry chapels in the south transept and a Victorian stained glass window showing the Tree of Jesse.

And what of Tideswell's history? Well, there is evidence of a Neolithic settlement which was followed by a Roman interest and then the Saxons. The settlement was given by William the Conqueror to William Peveril at Castleton (see above), and in 1802 it was bought by the Duke of Devonshire.

Tradition and history are important to Tideswell and its people who enjoy Wakes Week and the Grand Carnival. Again, the town's ebbing and flowing well was one of the 'Seven Wonders of the Peak', with four wells dressed on the Saturday nearest to St. Baptist's day, June 24th.

Whaley Bridge is a run of seven miles north from Buxton along the A5002. Beyond its collection of 19th century terraced houses. Not a great deal to see in the town centre itself, but try to find the Roosdyche. This is supposed to have been a Roman chariot race course. The Cromford and High Peak Railway made an impact here (see Chapter 4: 'Transport and Waterways') and today leisurely trips can be enjoyed on the Peak Forest Canal.

Parks and Country Homes

Haddon Hall. Should you decide to explore Bakewell, then leave enough time to admire the beauty of Haddon Hall and Chatsworth House. The first stately residence lies just two miles south of Bakewell with an entrance off the A6, and although just beyond our ten mile radius from Buxton, Haddon is well worth visiting.

Standing on a slope above the Wye, Haddon Hall has been in the Manners family since Dorothy Vernon, wife of John Manners, inherited it from her father in 1587. Since it was neither lived in nor renovated by its owners, the Dukes of Rutland, for 200 years, Haddon is one of the most complete medieval manor houses in England.

The Hall is approached from the Bakewell-Rowsley Road through the arch of the gate-house, along a pleasant drive and across the bridge which dates from 1633.

The Lower Courtyard comprises architecture from several periods, with a range of Tudor

buildings which housed the officials who administered the Vernon household and estates. It is in this part of Haddon Hall that we come across the museum and a 14th century Banqueting Hall. Keep a look out for two quaint medieval men appearing as gargoyles on the kitchen wall. The Lower Courtyard is overlooked by a host of interesting items such as the Tudor window of the old Parlour and the Earl's Bedroom.

The Chapel possesses examples of practically every stage in Haddon's building history. The circular pillar and font are Norman, the north aisle appeared in the 14th century, and the roof was replaced in 1624.

Built in the late 14th century by Sir Richard Vernon, the Banqueting Hall has a roof which was erected in 1923/25. A dais at the upper end of the Hall is a reminder of medieval dining arrangements where the family ate 'above the salt'.

Situated to the left of the entrance hall, the Kitchen's low ceiling was installed during the 16th century. The huge fireplace has a log box next to it, and beyond the Kitchen are the conveniently located Butcher's Shop and Bakehouse.

In the Duke's Bedroom the bed belongs to the first half of the 16th century, while the ceiling and oak panelling date from the following century. Within the Inner Chamber is a bed similar to the one just mentioned, together with some fine wood carvings.

Go down the stairs from the Inner Chamber and pause to look at the artefacts from the past in the Museum. These include a 17th century child's shoe, plus a lock and key from the same period. The charming Dining Room features a splendid fireplace above which are the arms of Henry VIII.

The Great Chamber dates to the 14th century with some modifications carried out in the 17th century. A room worth exploring if only to admire intricate moulded plaster work and beautiful 17th century Flemish tapestries. Just beyond this magnificent room is an ante-room and the Earl's sleeping quarters where there are more splendid 17th century Flemish tapestries.

Dating from 1589 this magnificent Long Gallery offers visitors the opportunity to examine panelled walls, heraldic glass windows and a plaster ceiling. A 110 feet long and a mere 15 feet high, the gallery is a light, airy room with windows on three sides.

Hunting scenes adorn the State Bedroom which is of 15th century construction, although the ceiling and plaster frieze are a later addition. From the bedroom the gardens and terrace are reached via the ante-room.

Occupying mostly the south side of the house, the impressive Gardens are laid out in a series of stone-walled terraces. In their present state the Gardens date to the early 17th century but clearly some had been here before. The River Wye adds much to the tranquil,

splendid settings of Haddon Hall from where, through mullioned windows, there are charming views of lush lawns and surrounding woodland.

Chatsworth House, like Haddon Hall, is just beyond our ten mile radius from Buxton but nevertheless, its charm and splendour are well worth sampling. Located on the B6012, Baslow to Matlock road, Chatsworth is one of the most famous houses in England and seat of the Dukes of Devonshire. The earlier sections in this book will have demonstrated how much influence was exercised by the Dukes over Buxton. For instance, the fifth Duke commissioned John Carr to build the Crescent in the spa town, while 1795 saw Duke's Drive constructed in Buxton. Again the sixth Duke provided a regular water supply to the town in 1840.

The splendid, Palladium-style exterior, magnificent parkland and exquisite interior of the house are matched by the priceless works of art at Chatsworth. The estate was acquired in the 16th century by Sir William Cavendish, whose son by Elizabeth Hardwick became Earl of Devonshire in 1618.

It has since been the principle country seat of the Cavendish family. Actually, the present home is the second on the site, the first being constructed by Bess of Hardwick and her husband, Sir William Cavendish. This was the prison of Mary, Queen of Scots in 1570 and 1573, and as we have seen above, she also spent some time in Buxton. The present house was built by the 4th Earl of Devonshire between 1685 and 1707.

Visit Chatsworth and you will be astounded by its unrivalled setting amidst gardens which are among the most spectacular in Europe. Enjoy the great Cascade, exotic trees, rolling meadows and the nearby River Derwent. While you are here, look for Queen Mary's bower, north west of the north entrance, between the river and the house.

The approach to the house is under the arch of the Porter's Lodge, and the north entrance hall served as a kitchen until the 1760s. The north corridor was formerly an open colonnade until its enclosure by the 6th Duke in 1841.

Measuring 64 feet by 36 feet, the magnificent Painted Hall provides a variety of attractions including oak stairs built by Wyatt, plus gilt ironwork on the gallery. The ceiling and walls depict the life of Julius Caesar and are the work of Laguerre who painted them in 1694. The Chapel, constructed in 1688-93, has changed little over the centuries, with local quarries supplying the altar piece of alabaster and black marble.

Approached by way of the staircase in the hall, the Great Stairs were originally intended to start from the ground floor. On the first floor landing are two baby carriages and a child's sleigh, while the Grotto supports the Great Stairs, and features the 'bas-relief' of 'Diana Bathing'.

Next we have a suite of five State Rooms taking up the total length of the south front where the Dining Room is the largest of the second floor State Rooms. Its ceiling dates from

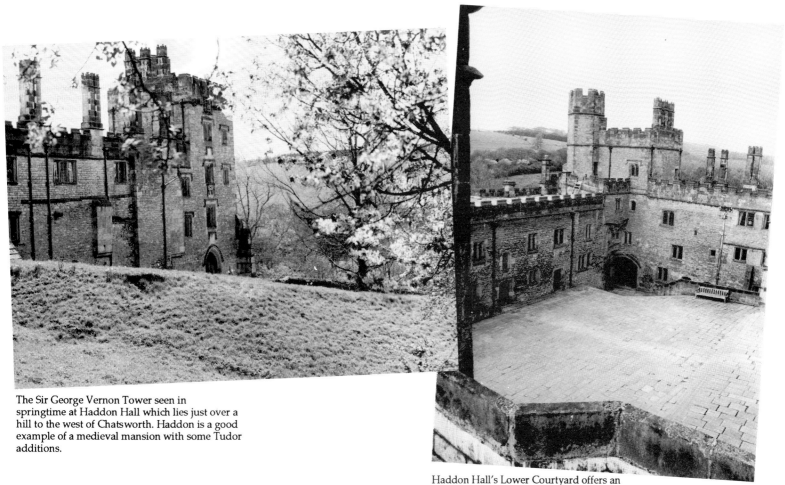

The Sir George Vernon Tower seen in
springtime at Haddon Hall which lies just over a
hill to the west of Chatsworth. Haddon is a good
example of a medieval mansion with some Tudor
additions.

Haddon Hall's Lower Courtyard offers an
interesting architectural mélange from varying
periods of time. Unity in style is achieved with
locally quarried grey building stones together with
paving stones and steps of the same material.

1691-92, the work of Verrio, and most of the gilt furniture was designed by William Kent. The Drawing Room tapestries should not be missed, woven at Mortlake in the 17th century, while the Music Room has an interesting painting on the inner door. So authentic is this work of art that for 150 years visitors have been tempted to reach out and touch Jan van der Vaart's painting to see if it was real!

The embossed and gilt leather on the Bedroom walls was placed there by the sixth Duke, while the bed belonged to King George II. Two large mirrors decorated with the arms of the 1st Duke and Duchess were made by John Gumley in 1703. The Dressing Room is the only one in the house with views to the south and west. Here an impressive silver chandelier carries the date of 1694.

On leaving the State Rooms go down to the Painted Hall, ascend the Oak Stairs into the Ante-Library and pause at the magnificent Library. You are not allowed to enter this room but its full splendour ,may be enjoyed from the Ante-room. Until 1815 the Library served as the first Duke's Long Gallery, assuming its present guise around 1830, and occupying most of the east front. There are over 17,000 volumes in the two libraries, together with some fine examples of early drawings and a portrait on an easel of Henry VIII dating from the 16th century.

The Great Dining Room is so named to distinguish it from the State Dining Room and three other similar eating places at Chatsworth. Various portraits by Van Dyck are found here, while the four heavy gilt tables were made especially for the room.

Passing from this part of Chatsworth House the Sculpture Gallery is entered with its three square lantern skylights. The sixth Duke indulged his passion for stone and sculpted figures in this room where works from a number of people may be enjoyed. These include pieces by Matthaus Kessels, Rudolf Schadow, Antonio Canova and Thorvaldsen. Leaving the Sculpture Gallery and passing through the Orangery, the visitor can step outside to the Gardens.

If a pleasant day out from Buxton is required, then why not visit the 'Palace of the Peak' in its large deer park bounded towards the east by moorland and watered by the Derwent. Check for opening times before exploring a magnificent house which has been open to visitors ever since it was built. In fact, travellers who wrote about Chatsworth in the 17th and early 18th centuries include Daniel Defoe and Celia Fiennes.

Lyme Park and its Hall, some considerable distance from Haddon and Chatsworth, are within a ten mile radius of Buxton. If you do not wish to drive, then take a train from the spa town, alighting at Disley which is close to the Park. For further details of the area, why not browse through the Author's books, *'Cheshire - A Portrait in Words and Pictures'* and *'Portrait of Stockport'*.

Lyme Hall, in the park of the same name, is a 600 year old National Trust mansion and deer

park financed and managed by Stockport Metropolitan Borough Council. The Park embraces some beautiful gardens, nature trails and of course the famous red deer.

An extensively renovated Elizabethan gritstone mansion dating from the 1560 period, Lyme Hall is perched 1200 feet above sea level in 1300 acres of wild moorland. Guided tours allow visitors to appreciate a collection of antique English clocks, Grinling Gibbons' carvings and rare Mortlake tapestries.

The Lyme Festival takes place for nine days each August, featuring displays, Morris dancing, folk and firework displays together with clay pigeon shoots. The famous Lyme Sheep Dog Trials attract many spectators and participants, while Summer Fun is a bumper holiday package of activities aimed at children. In short, one of the north's finest stately homes has something for everyone. Should you decide to drive from Buxton, then why not stop off at Whaley Bridge and Disley en route?

Beauty Spots

The Dove Valley is immensely fortunate in its natural assets, some three miles in length, running almost parallel with the Ashbourne-Buxton main road. The source of the River Dove is just east of the A53 Buxton-Leek road, facing Dove Head Cottage. Perhaps the best known spot on the river's journey is found between Hartington and the Stepping Stones, near Thorpe. Should you decide to follow the Dove's route, take a camera to capture the many fascinating sights such as Reynard's Cave, Lion's Head Rock, Ilam Rock and Pickering Tor.

The waters of the river have been immortalised in the *'The Compleat Angler'*. Since the author, Izaak Walton, and his colleague, Charles Cotton, cast their lines around Ilam, the waters of the Dove, Hamps and Manifold have tempted many anglers in search of trout.

Once you have admired wooded slopes rising from the river, why not pay a visit to the 'Izaak Walton Hotel' at Dovedale? This 34-bedroom establishment set in its English gardens, overlooks the entrance to Dovedale. You will be in good company since Tennyson signed the visitors' book and recorded his opinion that Dovedale was, 'one of the most unique and delicious places in England'. See if you agree with him!

Lathkill Dale has spectacular limestone crags to mark its beginning. Starting just half a mile from Monyash, the dale contains an unpredictable river, vanishing underground during the drier months and reappearing dramatically from Lathkill Head Cave.

The Lathkill is one of the few rivers rising in the limestone, its real source hidden underground where rainwater has found its way through joints and cracks. Making its way past Fern Dale and Cales Dale, the river meanders through a nature reserve, broadening out near Conksbury's medieval bridge. If you follow the course of the river, see if you can spot the

remains of Mandale lead mine with its engine-house and pillars of and aqueduct.

A mile or so from Conksbury the Lathkill is joined by Bradford Dale at Alport. Scenically, this must be one of the most beautiful dales in the area, and of course 1,230 feet up on the plateau between the Bradford and Lathkill rivers there is prehistoric Arbor Low. From here we can enjoy unrivalled views of the uplands between the Wye and the Dove. Perhaps the Lathkill may best be summarised in the words of Izaak Walton's friend, Charles Cotton, who commented that the river was, '...the purest and most transparent stream that I ever yet saw'.

Tegg's Nose. If you explore Macclesfield, then why not stop off at Tegg's Nose Country Park on the Buxton Old Road, close to the A537? The summit and slopes of the park area solidly based on gritstone, and visitors can enjoy a picnic site here in rugged Pennine country in Cheshire's eastern border. Find the 'viewpoint' in the car park which identifies the neighbouring hills, and if you feel like hiking, remember the park lies on the Gritstone Trail.

Macclesfield Forest is some 1,800 feet above sea level, with much of the timber employed as pulpwood for paper manufacturers or as fencing materials for local farmers. This area provides superb views of Peak District hills and Shining Tor, one of Cheshire's highest spots. But the name Macclesfield Forest should not simply conjure up a picture of coniferous trees. A small cluster of houses is named Macclesfield Forest and at the Forest Chapel one discovers the quaint Annual Rush Bearing Service. On the nearest Sunday to August 12th the floor of the Church is spread with rushes, a tradition dating from the time when rushes were used as floor coverings.

The Roaches, with its three mile long ridge, is some eight or nine miles south-west of Buxton. Taking their name from the French 'roche', the proud tor-like outcrop of rocks provides a good vantage point from where Cheshire and Staffordshire may be seen stretching away into the distance. The grotesque shaped rocks encourage climbers to tackle the heights which overlook the tranquil, pastoral Dane Valley.

Another elevated position, Gun Hill, stands between Rushton and Meerbrook, not far from Tittesworth Reservoir. A climb to the top of Gun Hill affords dramatic views of the Welsh hills, Jodrell Bank Radio Telescope and of course the reservoir.

Not too far away, Lud's Church is a narrow rift in the hillside, about a quarter of a mile long and some 50 feet deep. Local tradition suggests that services were held in this chasm by Friar Tuck for Robin Hood and his men when they hid from the Sheriff of Nottingham.

Mam Tor is referred to locally as the Shivering Mountain. Its looming bulk towers 1,695 feet high above the vales of Edale and Hope. Its nickname is derived from the breaking up of shale and sandstone which gradually slides down to the valley below. Local subsidence often results in the road up Mam Tor being closed to traffic, forcing vehicles to take the alternative Winnats Pass route.

Opposite:
Chatsworth House stands amidst a splendid setting, surrounded by 12,000 acres of farmland, woods and moorland belonging to the estate. The gardens are famous for the Emperor Fountain, Azalea Dell, and the Cascades, seen here just behind the Hall, on the right.

A walk to the summit of Mam Tor is rewarded by a splendid spectacle which takes in the Hope Valley, Millstone Edge and Hathersage. An Iron Age township existed on the top of Mam Tor and the remains of the highest fort in the Peak are still visible.

Winnats Pass is one of the most famous and dramatic limestone valleys in the Peak National Park. Owned by the National Trust the pass is traversed by a 1-in-5 road. The narrow gap in the limestone hills takes its name from 'wind gates', derived from the fierce gusts of wind which rush through the pass.

The old road from Buxton to Castleton climbs
through the spectacular Winnats Pass
(*National Trust*)